D1274262

THE CHICAGO
MUSIC SCENE
1960S AND 1970S

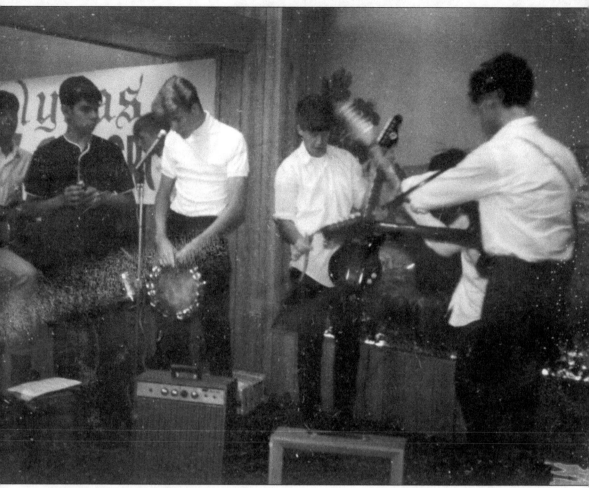

The author played his first paying gig at Richards Restaurant in Berwyn in the summer of 1966. He is the rebel in the dark shirt. He was paid $30, and it was a turning point in his life because now he was a "professional" musician, and he never looked back. Over the course of the next 43 years, he played in rock, country, bluegrass, folk, jazz, blues, Cajun, and show bands and savored every minute of it. He could never settle on just one genre of music; he loved it all. Luckily, Chicago had it all, and it allowed him to live his musical dream of playing every type of music imaginable. Those who played Chicago during the 1960s and 1970s were probably not aware of how good they had it, but looking back now, it was truly the best of times. (Author's collection.)

On the cover: Lonnie Brooks landed in Chicago in 1960 and quickly became a regular on the blues club circuit, playing his own style of music dubbed "voodoo blues." By the 1970s, the hardworking Brooks had released a record on Chicago's own Delmark label followed by recordings on several other labels, two of which were Grammy nominated. Band members included Harlan Terson, Billy Jackson, Bob Levis, and Rob Waters, among others. (Jim Quattrocki.)

IMAGES
of America

THE CHICAGO MUSIC SCENE

1960s AND 1970s

Dean Milano

ARCADIA
PUBLISHING

Published by Arcadia Publishing
Charleston, South Carolina

Library of Congress Control Number: 2009930134

For all general information contact Arcadia Publishing at:
Telephone 843-853-2070
Fax 843-853-0044
E-mail sales@arcadiapublishing.com
For customer service and orders:
Toll-Free 1-888-313-2665

Visit us on the Internet at www.arcadiapublishing.com

*For Joan Delaney (1934–2009), who was so excited about this project
and could not wait for the book to come out.
Wherever you are, I hope they have a library there.*

CONTENTS

ACKNOWLEDGMENTS

I would like to extend my grateful thanks to all those who contributed to this work in the interest of presenting as accurate a record as possible of a rather grandiose subject matter. Names of contributing sources are in parentheses following each photograph throughout the book. The Chicago Blues Archives, Music Information Center, Harold Washington Library Center, Chicago Public Library has been shortened to Chicago Public Library.

Thanks to those who contributed photographs, historical information, and general support: Sandy Andina, Christine Baczewska, David Baisa, Phil Barrile, John Benischek, Howard Berkman, Anthony Bianchi, Phillip Bimstein, Al Blatter, Bill Bobrowski, David Bragman, Michael Brook, Steve Brook, Lance Brown, Lee Burton, Andrew Calhoun, Jeff Carlson, Drew Carson, Bob Centano, Randy Chertkow, Chuck Christiansen, Mike Cichowicz, Otis Clay, Darryl Coburn, V. J. Comforte, Rich Corpolongo, Chip Covington, James Craig, Ron Crick, Bob Danon, Lino Darchun, Kal David, Richie Davis, Felicia Dechter, Elliott Delman, Linda Dellorto, Rick Dittemore, Mike Dooley, Mike Dugo, Josie Falbo, Jim Fine, Sally Fingerett, Dave Freeman, Tommy Furlong, Joan Gand, Carl Giammarese, Rob Gillis, Moses Glidden, Alan Goldberg, Phil Goldman, Masha Goodman, Rick Gordon, Ron Gordon, Ray Graffia, Skip Griparis, Ed Hall, Nancy Harless, Joel Harlib, Hugh Hart, Eric Hochberg, Ron Holder, Janice Horst, Larry House, Dave Humphreys, Dave Ivaz, Michael James, Alaric Jans, Jeff Jarema, Dennis Johnson, Steve Joyner, Steve Justman, Bruce Kallick, Kendell Kardt, Brian Keady, Cindy Keeling, Kathy Kelly, Rob Kleeman, Dave Kolars, David Kovnat, Colby Krouse, Jeannie Lambert, Quent Lang, Blanche LeBlanc, Mike Lerner, Ron LeSaar, Tom Lavin, Richard Levee, Jeff Libman, Tim Livingston, Gary Loizzo, Peter Longo, Gene Lubin, Terry MacNamara, Barb Malott, Marlene O'Malley, Laurel Palma, Gordon Patriarca, Simeon Pillich, Bo Pirruccello, Jim Polaski, Dick Reck, Ronnie Rice, Bob Riedy, Judy Roberts, Peter Ruth, Dave Samuelson, Claudia Schmidt, Troy Sepion, Corky Siegel, Scott Smith, Tracey Surface, Juel Ulven, Rick Veras, Tom-Tom Washington, Patricia Yeray, and Dan Zahn.

Thanks to those who went above and beyond the call of duty in helping me connect to the various photograph sources and to those who checked and double-checked my text for accuracy: Guy Arnston, Kirby Bivans, Greg Cahill, Donita Crenshaw, Bobby Diamond, Clay Eals, Chris Farrell, Carol Francis, Steve Hashimoto, Terry Jares, Jeffrey Jones, Lilli Kuzma, Colby Maddox, Jerry McGeorge, Paul Petraitis, Christopher Popa, Robert Pruter, Jim Quattrocki, John Rice, Dean Rolando, Byron Roche, Chris Shannon, Norman Siegel, Harlan Terson, Art Thieme, Alfred Ticoalu, Gary Tuber, Ken Utterback, Nick Warburton, and Russel Ward.

And thanks to my wife, Gay, who said to me, "Dean, you should write a book." And here it is.

This book is certainly not to be considered an all-inclusive work regarding the musicians and bands of the 1960s and 1970s. In order to include every player and band from that period, an encyclopedic work would be necessary, and perhaps that book will one day be written. Many players are absent from this book for various reasons, the most obvious being legal problems regarding permission to use photographs or the simple fact that a usable photograph could not be obtained. Space limitations also became a factor as multitudes of photographs began pouring in from all over the world.

However, many of the photographs that had to be cut are available for viewing on the Internet. E-mail Deanguy@ameritech.net, and a link will be provided to a site containing those photographs.

INTRODUCTION

What a Night! What a Night!

—Wally Frederichs, Chicago street musician extraordinaire

Chicago has always been known for its exciting live music scene going back to the 1920s when Bing Crosby and Benny Goodman entertained audiences in what was evolving as a world-class nightclub circuit. However, no one was prepared for the incredible cultural upheaval and social unrest that came with the groundbreaking new music being performed when the 1960s arrived.

Some of the more famous Chicago music clubs of the 1960s and 1970s (Mr. Kelly's, the RR Ranch, the Gate of Horn) were holdovers of an earlier era when nightclubbing was a more formal event that involved dressing up and heading to the Loop for a special night on the town, which usually ended at Fritzel's Restaurant. The famous State and Lake eatery was a great place to grab a late-night snack and rub shoulders with some of the stars passing through town. Beyond the upscale club circuit, there were the "pick up joints," as they were known, where a more informal atmosphere prevailed.

By the mid-1960s, the scene had begun to radically change, as did the atmosphere of the clubs. No longer were patrons seated by a maitre d' and led to a cozy, lamp-lit table in a smoke-filled room for an evening show. The smoke still remained, but a casual atmosphere of wandering in and out and socializing during the show became more common, particularly in the rock-and-roll clubs that were evolving, echoing the more laid-back attitude that was permeating the younger generation.

Thanks in part to the diversity of Top 40 radio, listeners were treated to a wide variety of music on their favorite stations. A typical WLS or WCFL programming day included not only rock, but also country, folk, jazz, showtunes, blues, and maybe even an ethnic tune. As a result, people were willing to listen to many different types of music, and there was certainly no lack of variety when it came to listening rooms on the popular club circuit. One could also find every kind of ethnic music imaginable from the various neighborhoods, including Mexican, Polish, German, Italian, Greek, Polynesian, Russian, and every country in between. The city has always been known for its gospel music, or church music, which had a profound effect on R&B, soul music, and eventually rock and roll. Add to that the world-class Chicago Symphony Orchestra and the Lyric Opera and one could call Chicago a very well-rounded musical town.

During the mid- to late 1960s, popular music was also tied into the countercultural movement that was spreading across the country. To the younger generation, music was considered owned by the people, and any corporate or advertising connections were absolutely taboo. Chicago organizations such as the Rainbow Coalition, Rising Up Angry, and the Cooperative Energy Supply held dances and benefits at places like the Midland Hotel, with the purpose of collecting food and clothing for the needy along with an attempt to raise political consciousness throughout the neighborhoods. It was a time of innocence that was eventually shattered once the corporate world became aware of how much money could be made off this new music.

Around the early 1970s, a major live music scene began to evolve along Lincoln Avenue north of the Loop. There seemed to be a new club opening up in any vacant storefront that could be found. Many rooms, such as the Quiet Knight in Chicago and the Heartland Café in Rogers

Park, prided themselves on the eclectic smorgasbord of music they offered. It was not uncommon to hear a rock band at a particular club on Wednesday only to wander in on Thursday to hear a folk duet or a jazz trio. And many customers looked forward to coming back every night, because the music was always good.

On certain nights, famous musicians from other venues in the area wandered into the late-night clubs, adding to the excitement of the scene. Invariably, an amazing impromptu jam session would ensue and last into the wee hours, to the delight of the unsuspecting audience.

For those who were not comfortable with the nightclub atmosphere, there was an array of outdoor festivals that began to emerge, particularly in the 1970s. No matter what is said about Mayor Jane Byrne, she was certainly a friend to Chicago musicians and was commonly referred to as the "party mayor." She not only heavily promoted Chicago Fest and Taste of Chicago, both huge opportunities for performing musicians, she also actively sought out ways to place musicians on street corners and in the parks for music events sponsored by the City of Chicago. A decent player or band could actually make a good living working the various music venues during that time period.

A relatively recent change in the club scene has been the police clampdown on drunk drivers. With the fear of receiving a DUI on the way home from a night of fun, clubgoers have cut their drinking intake back to more sane levels. However, many bar owners have seen their profits shrinking and the crowds thinning out by midnight.

In this era of deejays and lip-synched music performances, it is difficult for a musician older than 50 to describe to a younger generation what those years were like. The music was so vital to the world in terms of social injustice, civil rights, and opposition to war, that it makes today's world look somewhat pale in comparison. It is hoped the pages of this book can give just a glimmer of what it was like and what it meant to those who were there. Although the traditional music listening room today has been replaced for the most part by karaoke and sports bars, there are still a handful of appreciative music lovers searching out places to experience live music, and hopefully their ranks will grow and real music will thrive once again.

As many photographs as possible have been included on the following pages of Chicago musicians, but because of space constraints and the fact that, in many cases, it was difficult if not impossible to locate photographs of the bands and musicians who performed in Chicago during the 1960s and 1970s, there are obviously some omissions. Hopefully the sampling here gives a good representation of the era. Be sure to check the book addendum for a more complete listing of performers.

Something happened during the writing of this book that was not planned on. It was clearly going to be an educational experience, but there was no way to know what an emotional one it would become. Upon doing research, many tributes were found to musicians who have passed on since the end of the 1970s. Reading the tributes and stories of these wonderful musicians made it clear how loved these people were and how intensely their music affected everyone they touched. This book is going to touch that unexpected emotional chord in many who read it and gaze on the pictures that tell the story of this unique period in the history of Chicago and its music.

One

FOLK AND ACOUSTIC

They're my kids, my pals. I love 'em!

—Earl Pionke, on the folksingers working at the Earl of Old Town

Although folk music was already popular during the 1950s, the 1960s ushered in the era of the singer/songwriter, spearheaded of course by Bob Dylan. The days of simply leading traditional sing-alongs were fast coming to an end. A folk singer was now expected to say something about the current state of political and social events. With folk music on the cutting edge of the creative arts, the club scene began to thrive on the newfound young audiences. Change was in the air when in 1965 Dylan traded in his acoustic guitar for an electric Fender Stratocaster, but the scene held on for two solid decades, reviving itself with gusto in the 1970s. Chicago in particular became known for its crop of excellent songwriters, and several landed recording contracts, eventually achieving national acclaim.

There was also a large contingency of performers who kept the traditional folk song alive, and the University of Chicago Folk Festival anchored that particular scene over the years.

In the early days, Chicago folk clubs were scattered throughout the north side of the city in the Old Town and Rush Street areas, but the early 1970s brought a major concentration of venues along Lincoln Avenue between Wells and Sheffield Streets. One could walk down Lincoln Avenue almost any night of the week and come upon a multitude of clubs featuring eclectic folk acts.

One of the most wonderful aspects of the scene during that time was the large number of listening rooms on the circuit. These were the venues that people went to when they wanted to listen to the performers as opposed to drowning them out with their loud table conversation. And if the maitre d' or bouncer thought a party was a little too loud, the people were politely asked to leave. That sort of atmosphere is sorely lacking today, although some rooms still ask patrons to turn off their cell phones and refrain from talking during the performance. And the crowd happily complies, since the reason they go there is specifically to listen to and enjoy the music.

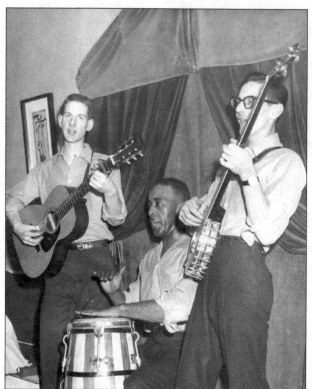

Quite a few musical luminaries have been associated with the Old Town School of Folk Music over the years, and one of them is Roger McGuinn, who later went on to found the Byrds. McGuinn was part of a trio called the Frets that also included John Carbo and Louis McDonald. The group became well known as the house band for the Gate of Horn and hosted its Sunday hootenannies. (Old Town School of Folk Music.)

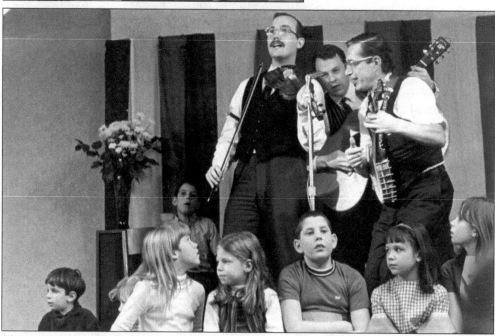

They were known as the National Recovery Act and consisted of Tyler Wilson on guitar, John Prine's brother Dave Prine on fiddle, and occasionally Fleming Brown on banjo. They were all associated with the Old Town School of Folk Music, and they are pictured here performing for a group of children at one of the school's many events. (Old Town School of Folk Music.)

The Armitage Avenue location of the Old Town School of Folk Music was and still is near and dear to the hearts of longtime folk musicians in Chicago. The building had a cozy and rambling interior with little rooms appearing at every corner. The list of performers who took the stage at the old location reads like a who's who of folk music from the 1960s and 1970s. (Old Town School of Folk Music.)

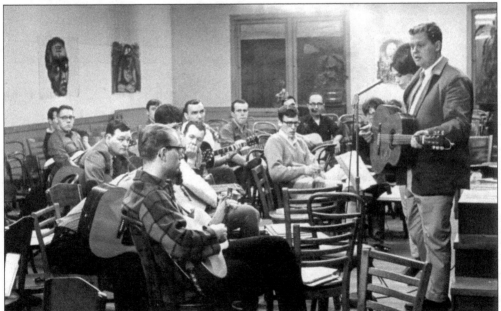

The Old Town School of Folk Music was the shared dream of its founders Win Strakke, Dawn Greening, and Frank Hamilton. It was to be a place where people could come to learn folk music and folk dance, among other subjects. Ray Tate, one of the longtime directors of the school, is seen here teaching a guitar class at the Armitage Avenue location during the 1960s. (Old Town School of Folk Music.)

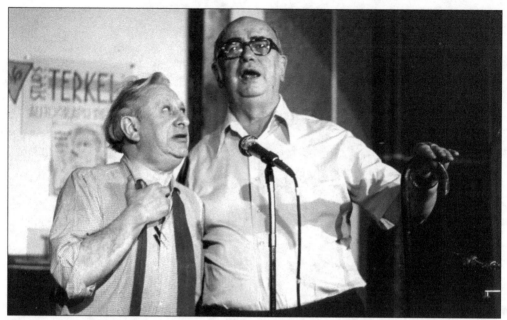

Win Stracke and Studs Terkel grab the microphone for an impromptu song at a book signing for Terkel's book *Working*. The author's band the Casualaires performed that evening for the event at the Armitage Avenue Old Town School of Folk Music location along with singer Jim Post. Stracke and Terkel both did much to promote folk music in Chicago through the Old Town School and WFMT radio. (Ron Gordon.)

Frank Hamilton's major contribution to the Chicago music scene was the cofounding, along with Stracke, of the Old Town School of Folk Music. Hamilton served as the original director and initiated the group-teaching methods that are still in use today. As a performer, he was one of the originals along with Bob Gibson and others at the Gate of Horn, the country's first folk music club. (Old Town School of Folk Music.)

Bob Gibson (left) became one of the pillars of the national folk music scene and the Chicago scene starting in the late 1950s. His appearances on television shows such as *Hootenanny* gave folk music a wide audience, and he was partially responsible for the folk music boom of the early 1960s. His collaborations with British-born Hamilton Camp and their performances at the Gate of Horn were legendary. (Left, Art Thieme; right, Old Town School of Folk Music.)

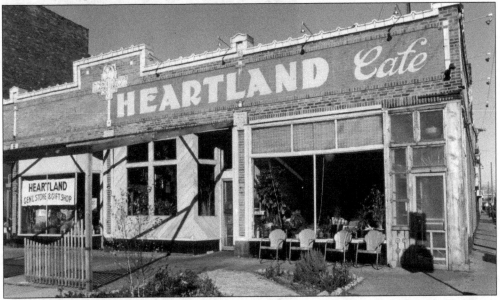

The Heartland Café opened in 1976, but its roots go back to the days of the Rising Up Angry music concerts Michael James helped organize to benefit the community. When Michael and his business partner, Kathy decided to expand their efforts, they found a business for sale and as they stood in front of the building on a rainy day and watched the clouds part and a rainbow form above, they decided to seal the deal. (Michael James.)

Folk music fans may remember 17-year-old Megon McDonough opening for such acts in the 1970s as John Denver, Steve Martin, and Harry Chapin. But McDonough classifies her music as folk/cabaret, citing her love of theater and jazz as the reason for the unusual mix. She wrote her first song at age 11 and was inspired to play the guitar and sing after watching the Beatles on *The Ed Sullivan Show.* (Megon McDonough.)

Art Thieme has been called "America's best loved troubadour" for good reason. His songs, stories, bad jokes, and puns have forever endeared him to audiences throughout Chicago and across the country. He has also become something of Chicago folk music historian via his personal Mudcat Café Web site filled with photographs of virtually everyone who played or sang on the circuit during the heyday of the folk music scene. (Art Thieme.)

Shel Silverstein called her "the best of the female folksingers." Jo Mapes should have been a star, but for a number of reasons fame eluded her, and after a grueling six years on the road, she retired to raise her children. She did not leave, however, without having a profound influence on the folk music community and the fans who never forgot her. She continued to play the Chicago club circuit through the 1970s. (Jo Mapes.)

It is difficult to categorize a musician like Kenneth (also known as Jethro) Burns. Should he go into the country, folk, or jazz chapter? The answer is, he could easily go into all three. He is probably best known as one half of the comedy team of Homer and Jethro, but after listening to him play, it immediately becomes apparent that he is more than just a comedian— he is a top-notch musician. (E. J. Stiernberg.)

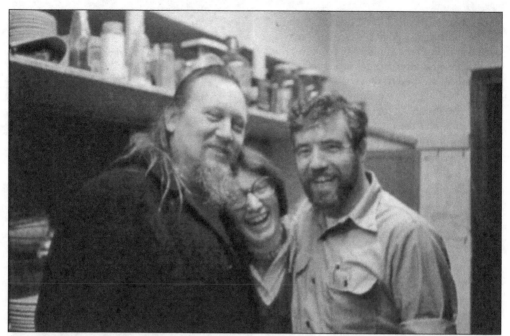

Earl Pionke (left), pictured here with Emily Friedman and Lou Killen, could have probably been called the "big daddy of the folk music scene" during the 1970s. He owned Somebody Else's Troubles and of course the Earl of Old Town on Wells Street. He supported folk music not only through the bookings he could offer in his clubs, but also he was known to help out many a starving musician when the chips were down. (Guy Arnston.)

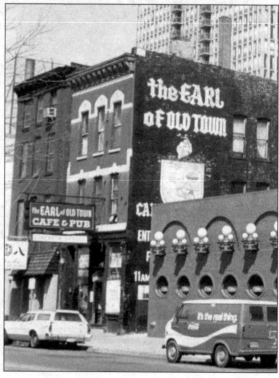

The Earl of Old Town was the gig every up-and-coming Chicago folk musician dreamed of during the 1970s. Once a musician played the Earl, he or she had "arrived" in Chicago. It was a wonderful place to play on any given night of the week, but the place looked different on a Sunday afternoon when one was expected to wrap up a weekend performing the 2:00 p.m. all-ages show. (Guy Arnston.)

EARL OF OLD TOWN
Holiday Calender

BONNIE KOLOC
Harry Waller
Tues.·Wed.·Thur. Dec. 16·17·18
2 Shows Nightly 9,11:15PM
·· 2nd Show·Reservations taken by phone

JIM POST
4 Weekends Fri.· Sat.· Sun.
National Recovery Act — DEC. 12-14
with Buffo — DEC. 19-21
 Tom Dundee — DEC. 26-28
 Mike Dunbar — JAN. 2-4

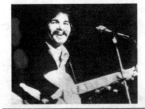

JOHN PRINE
National Recovery Act
MON.·TUES. DEC. 29-30
2 Shows - 8:30 + 11:15
Tickets on sale at EARLS & TROUBLES

STEVE GOODMAN
Saul Broudy
New Year's Eve & New Year's Day
WED.·THUR. DEC. 31-JAN. 1
2 Shows - 8:30 + 11:15
Tickets on sale at EARLS & TROUBLES
for information call 642-5206

Here are four giants of the 1970s Chicago folk scene, and the Earl of Old Town was *the* place to catch their shows. Bonnie Koloc came to Chicago from Iowa, and she quickly became a regular at the Earl. One of her best-known songs is her 1974 recording of "Roll Me On the Water." Steve Goodman was probably the most successful of the 1970s folkies, with his classic anthem, "City of New Orleans." An entire book has been written on his accomplishments by author Clay Eals. Goodman's New Years Eve shows at the Earl were legendary. Jim Post came from the pop music scene, having had a hit record in the 1960s with his duo, Friend and Lover. He went on to enjoy a very successful career in folk music. Ex-mailman John Prine was actually discovered by Kris Kristofferson at the Earl of Old Town one night when Goodman convinced Kristofferson to come on by after hours and give Prine a listen. He was first thought of as the new Bob Dylan, but he quickly established his own unique identity. (Norm Siegel.)

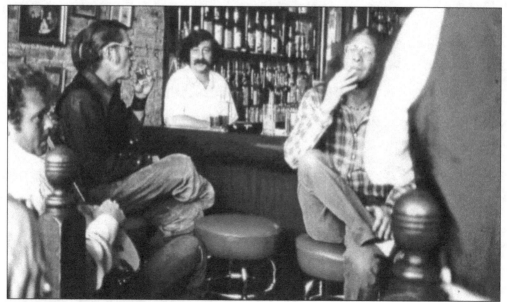

Ed Holstein has always been a bartender disguised as a folksinger. An accomplished musician and songwriter (one of his originals, "Jazzman," has been recorded by an impressive number of artists), he always seemed more comfortable tending the bar at Somebody Else's Troubles, the club he helped manage. Listening to him onstage, sometimes rather than singing, one would be happy just listening to him talk, shooting the breeze—like any good bartender did. (Bruce Kallick/Art Thieme.)

One of the best listening rooms in the city was named after Steve Goodman's second album, Somebody Else's Troubles. Every top folk act in the city performed there along with every major name coming through Chicago. The music was primarily folk, but every once in a while, owner Earl Pionke would book an esoteric act, such as the author's band, The Casualaires, much to the chagrin of manager and folk purist, Fred Holstein. (Art Thieme.)

Fred Holstein was one of the mainstays of the Chicago folk music scene throughout the 1970s. He and his brother Ed managed the folk club Somebody Else's Troubles, owned by Goodman, Earl Pionke, and Bill Redhed. The Holsteins eventually opened their own club called—appropriately enough—Holsteins. Fred Holstien had a very gentle approach to his performances, and as Kimmer Macarus once said, "He just made you feel all warm inside." (Michael James.)

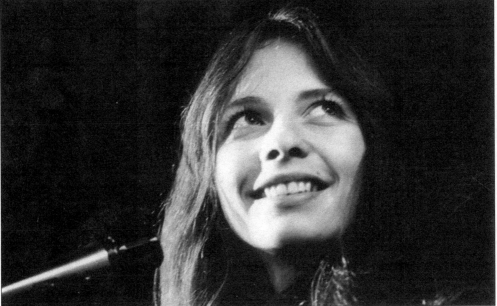

June Shellene first came to Chicago with Roscoe, a folk-rock band popular on the Lincoln Avenue circuit in the early 1970s. She later soloed and played in small ensembles, doing a mix of original songs and pop, blues, and jazz covers. She sang backup for the Al Day Band, the David Bromberg Band, and Rokko and the Hat, as well as taking on accompanist and musical directing chores at several Chicago theaters. (June Shellene.)

Two Way Street coffeehouse in Downers Grove, run by Dave Humphreys and his cast of loyal volunteers, has been going strong every Friday night since 1970. The amazing thing about Two Way Street is the fact that for a fairly small room, it has consistently managed to have the highest-quality performers on the folk music circuit, featuring national as well as local acts. (Dave Humphreys.)

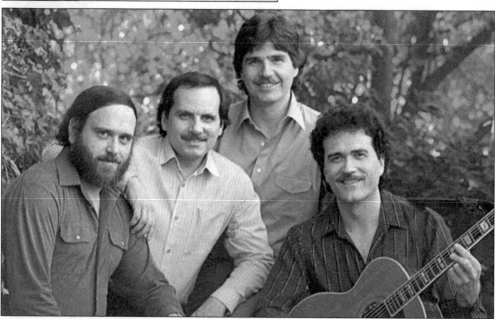

The Dooley Brothers actually are brothers (Bill, Joe, Mike, and Jim) and have been performing continuously since the late 1960s, playing at dozens of Chicago area clubs and venues. They still perform on a regular basis today. Over the years, the band played an interesting mix of folk, country, originals, and music from the 1930s and 1940s, singing those wonderfully blended harmonies that only siblings can muster. (Mike Dooley.)

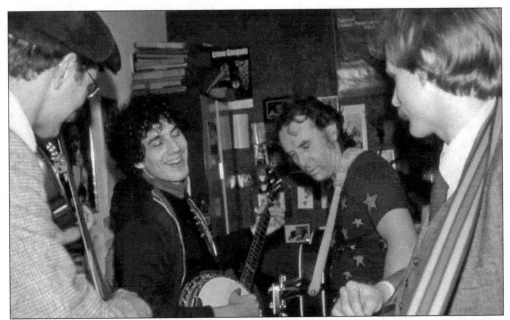

From left to right, Colin McCoy, Stephen Wade, Jim Post, and Wade Miller are seen at an impromptu jam session. This photograph was taken around the time Stephen's Banjo Dancing show was coming together, a show he eventually performed at the White House. Chicago folk musicians considered themselves one big family, and they loved to play together at the drop of a hat. One can almost hear the music just by looking at the faces in this picture. (Art Thieme.)

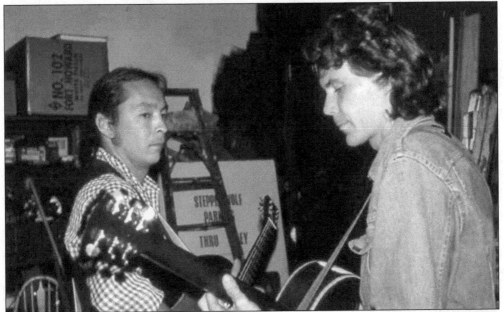

Mick Scott (left) and Tom Dundee were very active on the Chicago folk scene during the 1970s and worked quite frequently as a duo playing Chicago clubs and traveling across the country together. Each performed as a single act, however, and they were both equally talented as guitarists, singers, and songwriters. Dundee's most famous tune was undoubtedly "A Delicate Balance," and Mick's was "Last One of the Night People," both wonderful songs. (Art Thieme.)

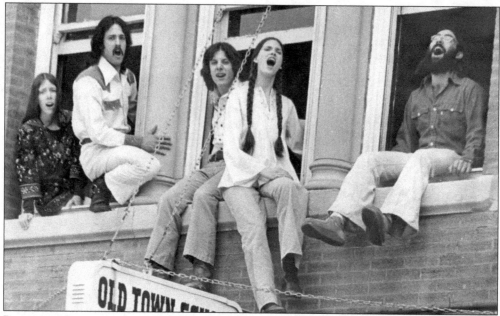

Ravenswood was an acoustic folk group that Ray Tate designated and referred to as the official professional performing group of the Old Town School of Folk Music. The band started out performing weekly at the Northside Auditorium Bar and eventually moved on to a regular slot at Somebody Else's Troubles. Included in this 1976 photograph from left to right are Cindy Mangsen, Chris Farrell, Josh Frankel, Mitch Thomas, and Steve Levitt. (Chris Farrell.)

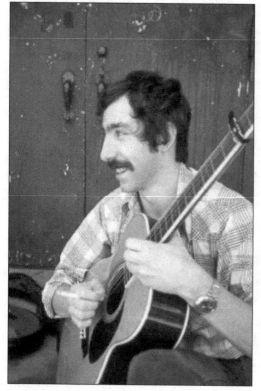

Although Jim Hirsch is a fine finger-style guitarist and musician in his own right, he is probably best known as the man who took over the directorship of the Old Town School of Folk Music after Ray Tate's departure. Hirsch was a phenomenal fund-raiser, and some would even say he was largely responsible for the continuing existence of the school during his watch. (Art Thieme.)

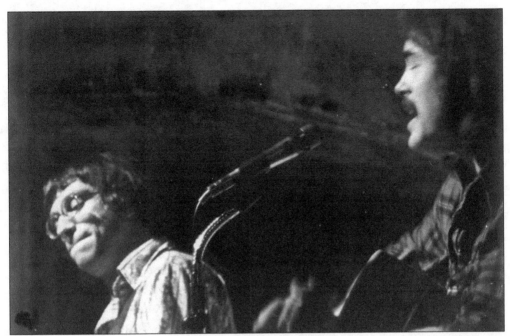

Two very talented folk musicians, John Benischek (left) and Jeff Jones, are seen here performing at the Barbarossa, a small club that specialized in live acoustic music. Both men were songwriters as well as musicians, and they each teamed up with a variety of other acts over the years and performed on their own. (John Benischek.)

Wally Frederichs was one of the best-known Chicago street musicians of the 1970s and probably one of the largest too. Known as "Big Wally," he was an excellent banjo player, and his rendition of "Somewhere Over the Rainbow" was a showstopper. In his earlier days of playing, he teamed up with several local musicians, including Bob Hoban, later of the Famous Potatoes fame. (Art Thieme.)

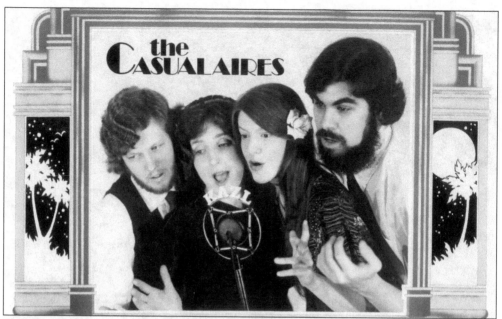

The Casualaires were one of the more unique aggregations on the Lincoln Avenue folk scene of the 1970s. Its members included Rick Shryock, Julianne Macarus, Jean Gordon, and Dean Milano, and its repertoire consisted of a mixture of 1930s and 1940s jazz and show tunes along with more traditional folk chestnuts. The exquisite four-part harmonies and complex arrangements set this group apart from many others. (Author's collection.)

The Martyvishnu Orchestra was a total fun and somewhat-crazed band made up of individual performers who were quite established in their own right on the Chicago scene. Marty Peifer, the leader of the group, sang hilarious parodies and also performed as a single act. Fellow singers/songwriters Al Day and John Benischek were also members. Keyboardist Bob Long was one of the founding members of the band Streetdancer. (Art Thieme.)

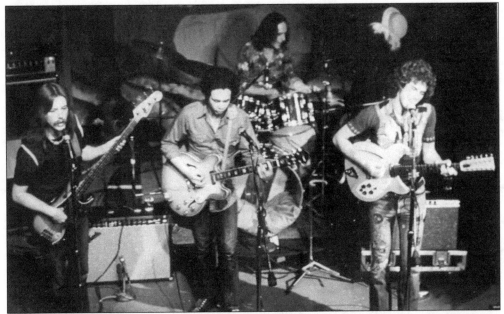

Bill Quateman should have been one of the Chicago acts to break through in the 1970s, but although all the elements were there, among them a large catalog of quality original music, somehow fame eluded him. He played the folk scene during his Chicago years, but his esoteric style made him hard to categorize. Several of his compositions were recorded by major artists, however, and Quateman is still a very popular artist today. (Paul Petraitis.)

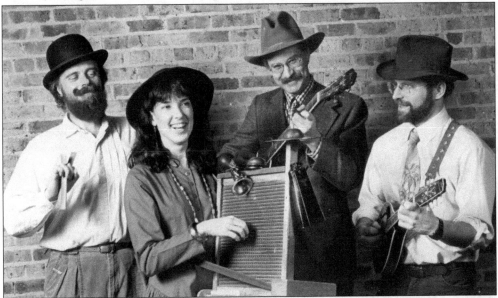

"Originally formed to play for spare change on city streets, the Laketown Buskers are reduced by hard times and unfriendly police officers to playing night clubs and concert auditoriums." This deft quote defines Busker and captures the humor and infectious fun that characterized the band. Garrison Keillor called them "hot," and upon hearing them perform, Odetta declared, "That was delicious." Members in this photograph (from left to right) include Bob Stelnicki, Barb Silverman, Colin McCoy, and Eric Mohring. (Author's collection.)

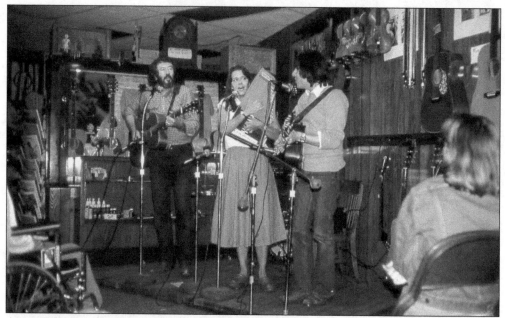

Anne Hills moved to Chicago in 1976 where she teamed up with Jan Burda to form Hogeye Music, a record label and a combination music store/folklore center that is still going strong in Chicago. Hills and Burda also performed together until they went their separate ways, and to this day, both enjoy very successful music careers. In this photograph, they are joined by guitarist Josh Frankel at a Hogeye Music performance. (Art Thieme.)

Byron Roche started playing guitar and singing as a child and began performing at age 15 in and around St. Louis. He moved to Chicago in 1974, played the clubs and the college circuit, and eventually became an entertainment agent. Roche later became an art dealer and opened a gallery in Chicago. He has presented performances there over the years by many musical artists and continues to play music himself. (Byron Roche.)

"A gig at the Earl Of Old Town was one of the jewels we were all reaching for," according to Chris Farrell, seen here performing at the Earl. Farrell came to Chicago in 1975 when many young singer/songwriters were moving here, attracted by the success of John Prine, Steve Goodman, and others. In 1976, he became a member of Ravenswood, the official professional performing group of the Old Town School of Folk Music. (Daniel D. Miller.)

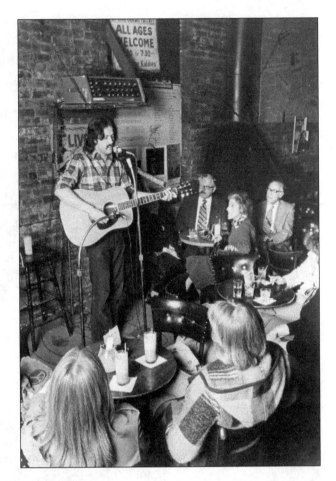

Formed by schoolteacher Christine Baczewska, conceptual artist Sher Doruff, and philosophy doctoral candidate Victor Sanders, Care of the Cow was one of the more unusual and interesting musical groups on the Chicago folk scene in the 1970s. Doruff was known for writing songs with tarot cards, and even the name of the band came from the tossing of the I Ching. (Christine Baczewska.)

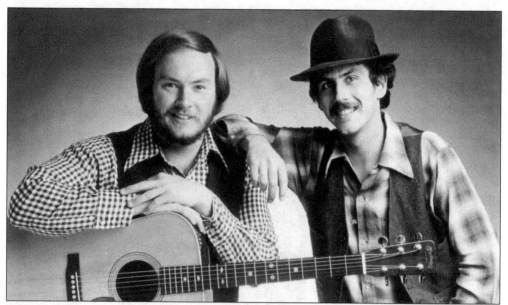

Jeff Friedlander and Ed Hall were an acoustic music duo deeply rooted in the Chicago folk music scene during the 1970s. They were based in Illinois but performed throughout the country. They were both accomplished guitarists backing up Friedlander's vocals, and although their music focus varied through the decades, it was basically bent toward acoustic swing, instrumentals, comedy, and songwriting. They also performed and recorded with Doug Lofstrom and Don Stiernberg. (Ed Hall.)

Andrew Calhoun's earliest performances were with the Osbornes, a group comprised of himself, his brother Matthew, and Doug Tursman. At age 13, Andrew began writing songs and performing in coffeehouses as a solo act. At age 15, he lied about his age and worked all summer to earn the money for a guitar and began playing open stages at various folk clubs. He eventually found paying work at those venues. (Andrew Calhoun.)

There is a large mountain of songwriters in Chicago, and somewhere near the very top sits Michael Smith. Among some of his most famous compositions are "The Dutchman" and "Spoon River," but he is also highly regarded as a singer and guitarist, and his live performances can be electrifying. Smith settled in Chicago in the early 1970s, and he and his partner, Barbara Barrow, immediately became a major presence on the folk music club circuit. (Author's collection.)

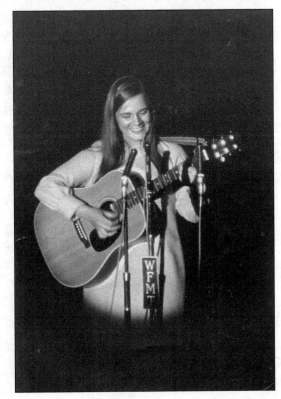

Ginni Clemmens was a singer/songwriter who spearheaded the landmark LP "Gay and Straight Together" on her own Open Door Records label. The work is now registered with the Smithsonian as a historically significant recording, being the first of its kind. Clemmens's life was cut short in an automobile accident, and an important voice was lost. (Old Town School of Folk Music.)

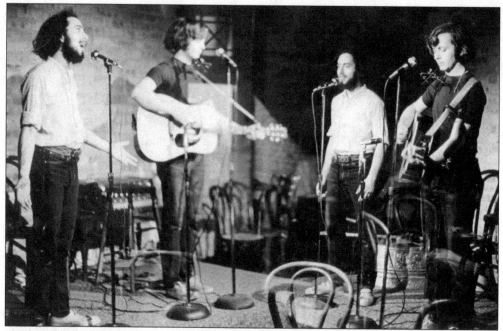

A fine singer and guitarist, Larry Rand was better known for his clever satires of popular songs, such as "Dust Up My Nose," a takeoff on a hit song by the group Kansas. His shows got even zanier when abetted by comedian Rich Markow (left), seen with him here at Orphans nightclub. Rand's between-song patter was hilarious. (Rich Markow.)

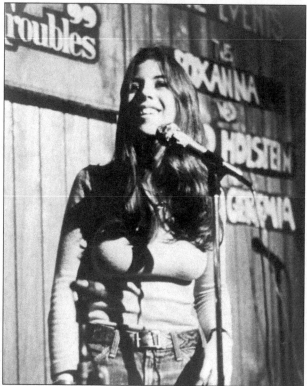

Sally Fingerett joined the Chicago folk scene while a student at the University of Illinois at Chicago, inspired by such artists as Steve Goodman and John Prine. She later went on to become a founding member of the Four Bitchin' Babes, an all-female band. She is pictured here in the 1970s on the stage of Somebody Else's Troubles, the famous Lincoln Avenue folk music club. (Sally Fingerett.)

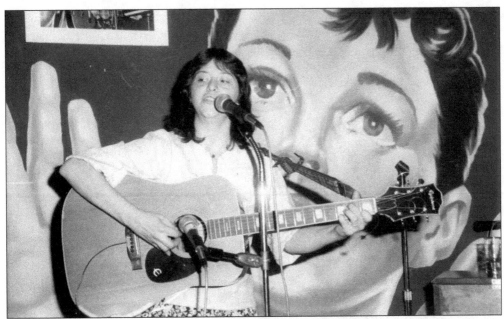

Tricia Alexander has always prided herself on her unique interpretations of other people's songs, but she is an accomplished songwriter as well. The list of musicians she has shared the concert stage with reads like a who's who of the Chicago music scene. In this photograph, she appears at Marge Summit's His 'n Hers, a club that welcomed performers of any sexual orientation at a time when that was quite rare. (Marge Summit.)

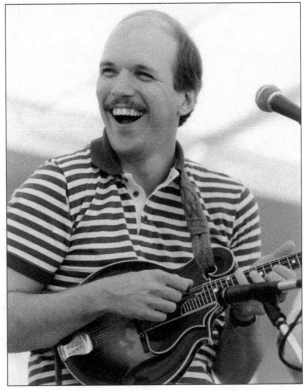

Don Stiernberg is another one of those players who is hard to categorize. One week he is playing bluegrass, and the next week it is jazz followed by country. He is first-rate in every category. Apparently mandolin players are like that. Stiernberg made his mark in the 1970s playing with the Jump 'n the Saddle band and eventually worked with Jethro Burns as well as several other bands. (Don Stiernberg.)

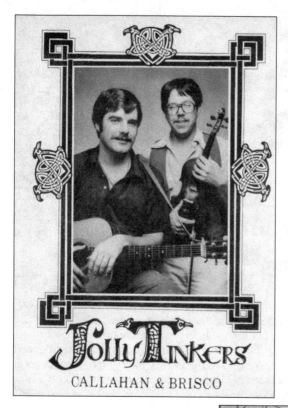

JollyTinkers
CALLAHAN & BRISCO

Stuart Rosenberg has been a favorite on the Chicago music scene for many years, delighting audiences on the violin, mandolin, and guitar. He played jazz with the Casualaires and Airflow Deluxe, but he is also a master of Irish, Klezmer, and folk music. He is pictured here with Pat Callahan (left), using the names Callahan and Brisco for their duo, the Jolly Tinkers. (Stuart Rosenberg.)

Thom Bishop is a gifted singer/songwriter/playwright who performed at the Earl of Old Town, Orphans, and other clubs throughout the 1970s. He had the distinction of writing three musicals that ran simultaneously in 1979, a feat never duplicated in Chicago musical theater history. Perhaps his greatest talent was reciting the entire first chapter of *The Catcher in the Rye* while changing a broken guitar string on stage. (Ron Gordon.)

Two

BLUES, R&B, AND SOUL

Ladies and gentlemen, we're gonna get down. We're gonna get down in the alley!

—Junior Wells at the start of his show

Legendary bluesman Robert Johnson called it "Sweet Home Chicago," spreading the word that Chicago was a sweet home for the blues.

During the 1930s and 1940s, the great migration to the north brought with it a form of acoustic music known as the Delta blues. When Muddy Waters and Chester Arthur Burnett (also known as Howlin' Wolf) came to Chicago after World War II and sang the blues to the sound of an electric guitar, a new sound was born, and that sound had found a new home. Chicago is probably more famous for the blues than any other form of music, and the blues always thrived in the city, particularly on the south and west sides and along Maxwell Street. During the 1960s and 1970s, Chicago's reputation as the "home of the blues" made it a magnet for blues artists the world over who were interested in finding the roots of the music they loved.

More so than the other forms of music, the blues in Chicago was blessed with several record labels, including Chess, Vee-Jay, and Delmark, dedicated to that genre of music. Not only was it easier for local musicians to land a decent recording contract, but it was also a means of enticing many national acts to record and perform here. Some of the most exciting events of the 1970s were the nights when the Rolling Stones dropped in unannounced at Chicago clubs to jam with the local players.

During the late 1960s, the blues began to lose its connection to daily life in the African American community, but the music found a new life drawn from young audiences searching out the roots of rock-and-roll music. Slowly, a network of blues clubs began to appear on the north side of the city, and the new fans were ready and waiting along with the tourist trade, which equated Chicago with the blues and wanted to get a taste of "the real thing."

Of course, it is natural to assume that Chicago also had a thriving R&B and soul music scene during those decades, and some of those artists are also covered in this chapter.

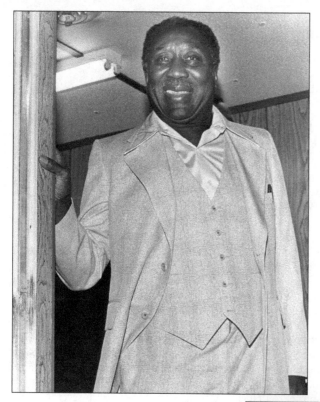

Muddy Waters almost single-handedly changed the sound of the acoustic Delta blues into the newer form of the electric blues, which has also been identified as a Chicago sound. Although he was never able to recapture the momentum of his 1950s accomplishments, he continued performing throughout the 1960s and 1970s, and one of the high points of his popularity came as a result of his appearance in the film *The Last Waltz*. (Jim Quattrocki.)

Bassist Willie Dixon was undeniably one of the most important influences on the post–World War II Chicago blues sound, and he eventually became a major touchstone for a rock-and-roll generation updating his songs. In addition to playing bass and writing for artists ranging from Muddy Waters to Chuck Berry and Bo Diddley, he also supervised most of the studio sessions at Chess Records beginning in the 1950s. (Chicago Public Library.)

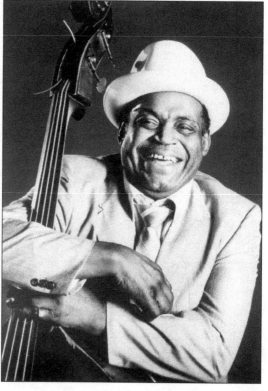

Junior Wells came north from Tennessee though Arkansas, but once he got here, he became a Chicago bluesman. He is well known for his work with Buddy Guy in the 1960s, and his version of "Messin' with the Kid" has become a staple of blues bands everywhere. He also featured Guy on his *Hoodoo Man Blues* album, with a sound that brought the feel of Chicago blues clubs to the world. (Chicago Public Library.)

Somewhere along the line, he was given the nickname "Magic Sam," and there is no denying he made magic with his music. After a dishonorable discharge from the army, Sam Maghett lost his way, but a comeback in the early 1960s signaled the start of a new career, which was sadly cut short by a heart attack at the age of 32. He was inducted into the Blues Hall of Fame in 1982. (Chicago Public Library.)

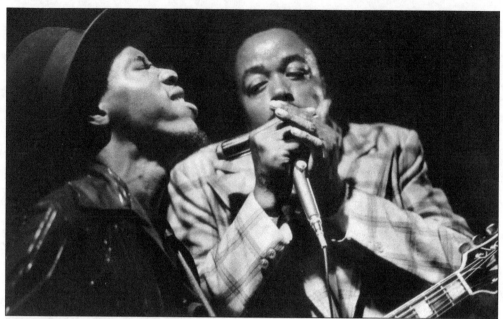

Carey and Lurrie Bell were a father-and-son team, with father Carey's history in Chicago blues going back to the 1950s. Carey learned harmonica techniques from the master players of the day, but in order to pay the bills, he took up the bass guitar. He eventually returned to his first love, the harmonica, and played the blues with his son. Carey passed away in 2005. (Chip Covington.)

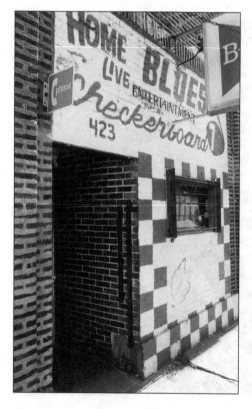

This is the original Checkerboard Lounge, where much of Chicago blues history was made. This is where Muddy Waters jammed with the Rolling Stones, where Junior Wells made his mark, and where Buddy Guy recorded an amazing live album. With its beautiful folk art painted exterior and its funky interior, the Checkerboard was always *the* place to go to find the real deal in Chicago blues. (Peter Amft.)

One hears the stories about great blues legends who came from a sharecropping family in the South, but in the case of "Little" Milton Campbell, the story is true. Campbell was discovered by Chess Records and brought to Chicago, where his hit records of the 1960s, such as "We're Gonna Make It" and "Baby I Love You" are now recognized as bona fide blues classics. (Chicago Public Library.)

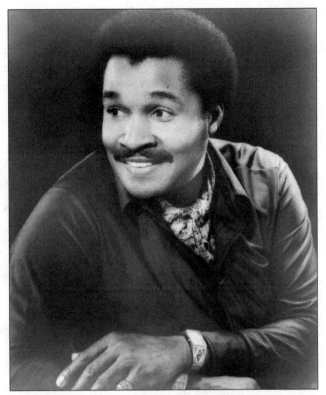

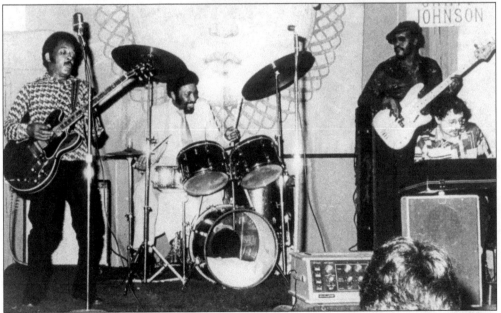

Coming from a family in which all his younger brothers were making music, it made perfect sense for Jimmy Johnson, "the Blues Preacher," to want to follow suit. And once he decided on a musical career, he moved from Mississippi to Chicago and hit the club circuit. After 20 years as an R&B artist, he pursued his real love—the blues, recording a string of award-winning hit records. (Lucy Swope.)

Born in Mississippi, Tyrone Davis headed north and eventually ended up in Chicago where he started singing his smooth soul style in local clubs. He is probably best known for his hit record "Turn Back the Hands of Time" from 1970, but he actually recorded more than 25 singles during the next few years and had several more top-10 hits throughout the decade. (Chicago Public Library.)

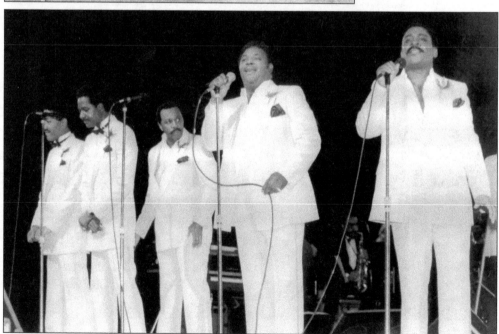

Formed in Harvey in the early 1950s, by 1960, the Dells had become Dinah Washington's backup group and began a new phase of their long career. The group had hit records on several labels, including Cadet, Vee-Jay, and Chess. They are also considered one of the longest-running vocal groups in rock-and-roll history, celebrating 50 years as a group. (Robert Pruter.)

Buddy Guy is a legend among Chicago blues musicians, and even the name of his nightclub, Buddy Guy's Legends, reflects that. It is said that a young Jimi Hendrix used to sit by the stage at Guy's concerts with a small tape recorder so he could study the amazing licks he heard coming out of that guitar. Guy went on to win five Grammys for his highly influential record albums. (Paul Petraitis.)

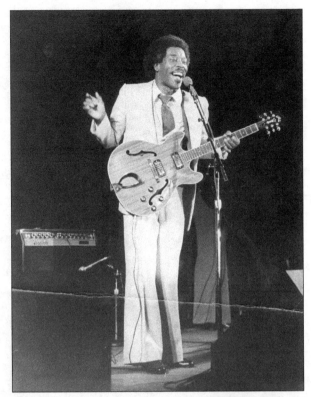

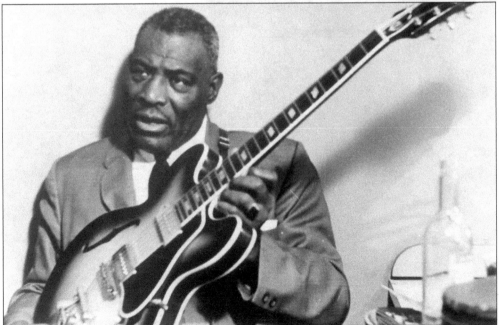

There is no doubt about the influence Howlin' Wolf had not only on the Chicago blues scene but also blues music in general. When he came to Chicago and plugged in his guitar, he helped to create a new sound that defined the modern blues. Revered by the top rock musicians of the day, he recorded with several of them in England in the 1970s. (Larry House.)

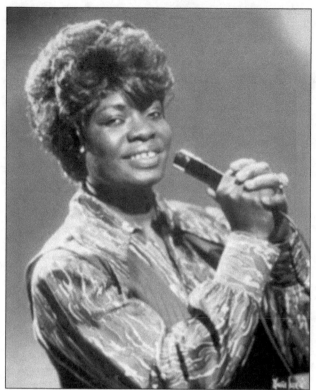

Probably best known for her million-selling 1966 hit record "Wang Dang Doodle," Koko Taylor had long been one of the dominant female blues singers of the genre. Taylor moved to Chicago from Tennessee and was eventually discovered by Willie Dixon while singing with Johnny Twist in northside blues clubs. She went on to an award-winning career and performed regularly until she passed away in 2009.

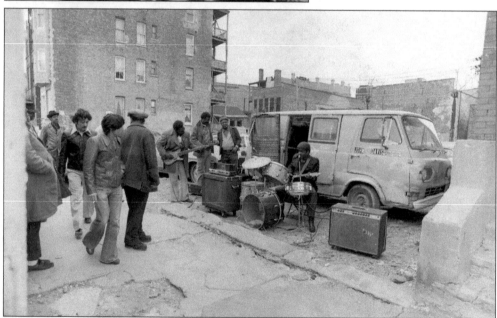

Thanks to the 1977 film *The Blues Brothers*, Maxwell Street became known throughout the world as a Chicago blues landmark. Musicians could be heard on the sidewalk any day of the week while bargain hunters hurried by, and many a famous player got started on the street. John Davis, seen here set up in front of his van, played on Maxwell Street for over 30 years. (Jim Quattrocki.)

Known as "the Iceman" because of the cool way in which he delivered highly emotional songs, Jerry Butler had a major impact on popular R&B music during the 1960s. As a teenager, he teamed up with fellow gospel singer Curtis Mayfield to form the Roosters, a vocal-oriented group that later changed its name to the Impressions and went on to enjoy a series of hit records. (Chicago Public Library.)

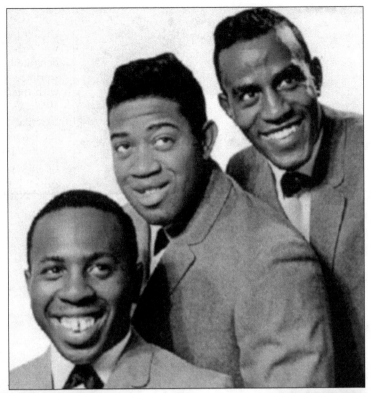

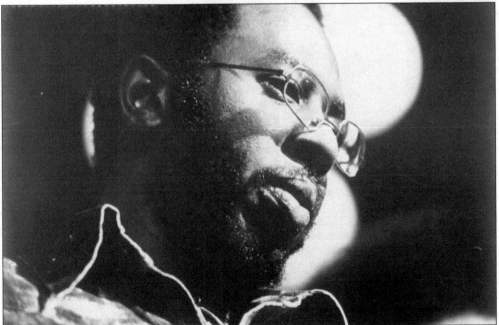

Mayfield dropped out of Wells High School in Chicago when he joined the Impressions. He soon found success on his own when his solo career took off with a string of hit records in the 1970s. His unique guitar stylings and falsetto vocals were his musical trademark, but he was also a pioneer in the field of lyrics that touched on political and social commentary. (Chicago Public Library.)

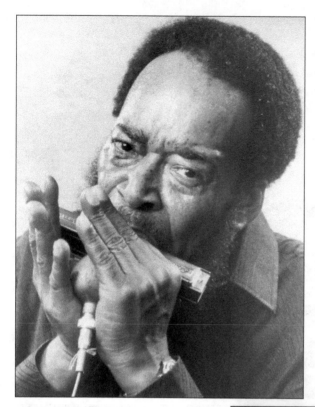

James Cotton's love affair with the harmonica started when he was a child, and his playing has delighted audiences around the world ever since. After working with the Muddy Waters band in the 1960s, Cotton decided it was time to strike out on his own, entering the burgeoning blues-rock scene of the late 1960s and recording several hit albums, as well as performing with many major acts of the day. (Paul Natkin.)

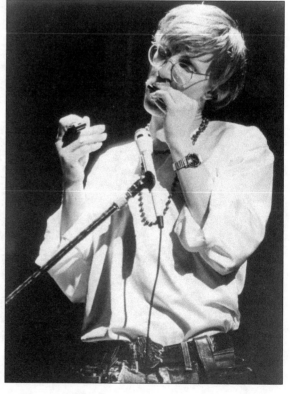

Peter Madcat Ruth started out as a folk musician, taking guitar lessons at the Old Town School of Folk Music, but after listening to a few blues albums, he became hooked on blues harmonica and never looked back. By the time he had taken several years of lessons with legendary Chicago blues harmonica player "Big" Walter Horton, he was ready to get serious about his playing and hit the road. (Byron Roche.)

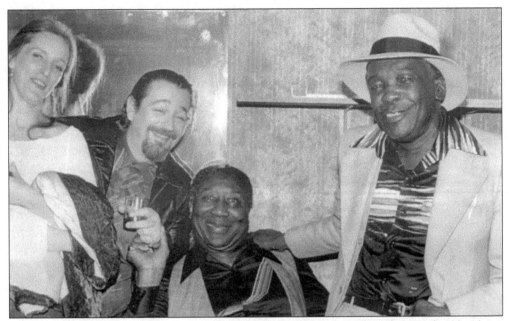

Charlie Musselwhite, the inspiration for Dan Akroyd's character in *The Blues Brothers*, has been called a "white bluesman," even though he claims Native American heritage. Born in Mississippi, he moved to Chicago and immersed himself in music, living in the basement of the Jazz Record Mart until he formed his own band and eventually recorded over 20 albums. He is pictured here with wife, Henrietta, Muddy Waters, and John Lee Hooker. (Randy Bachman.)

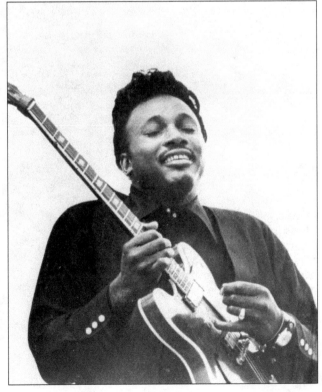

Otis Rush has been a major influence on blues and rock guitarists for decades. His unique guitar style became known as the west side Chicago blues sound, combining heavy chords and hot licks. Rush recorded for Cobra, Chess, and Delmark Records in the 1960s but retired from performing and recording at the end of the 1970s only to return to the stage in 1985. (Chicago Public Library.)

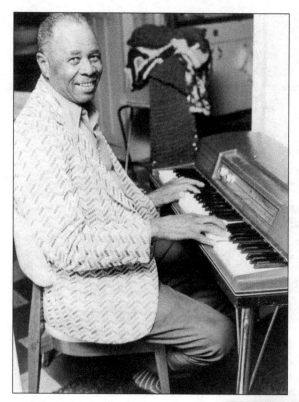

Albert "Sunnyland Slim" Luandrew moved to Chicago from the Mississippi Delta in the early 1940s and soon began playing the blues club circuit with Muddy Waters and Howlin' Wolf, among others. His style is considered one of the most influential of the early piano players, so much so that the Chicago Blues Festival often holds tributes to him to this day. (Chicago Public Library.)

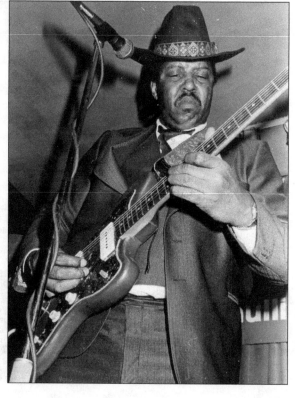

Morris Holt came to Chicago from Mississippi in 1955. Nicknamed "Magic Slim" by his friend Magic Sam, he played bass in Sam's band but did not impress anyone with his playing and ended up heading back south. By 1965, however, he was back in Chicago, this time as a guitar player. With his brother Nick, he formed the Teardrops and took the city by storm, eventually recording several hit records. (Chip Covington.)

Born in Louisiana, Joseph "Mighty Joe" Young eventually wound his way up to Chicago in the late 1950s and found himself playing guitar in Howlin' Wolf's band. Young formed his own band after playing with several well-known blues acts over the years, including those of Otis Rush and Willie Dixon. By the 1970s, he had several albums of his own material released on the Delmark and Ovation labels, among others. (Chicago Public Library.)

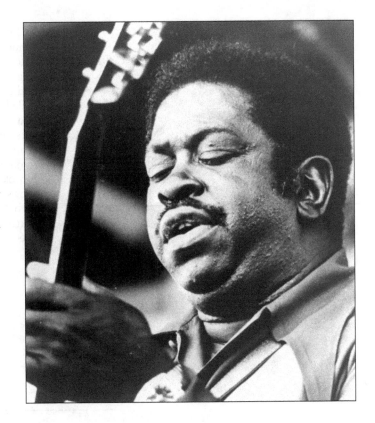

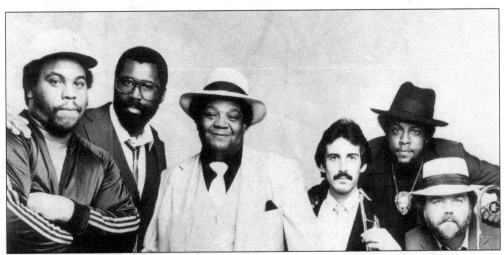

Larry Nolan, better known as "Big Twist," was beloved by Chicago music fans and was equally mourned when he passed away in 1990, leaving a void in the Chicago blues/R&B scene. He came to town in the 1970s and eventually recorded three excellent albums with his band the Mellow Fellows, and they are a great example of the Chicago sound. His unique style will never be forgotten. (Chicago Public Library.)

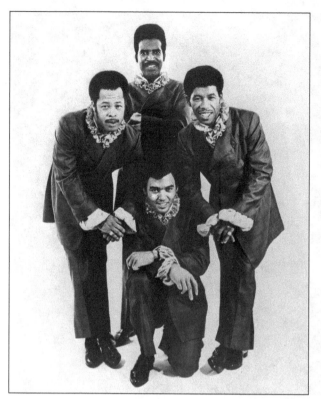

In 1960, Marshall Thompson formed the Chi-Lites along with fellow musicians Creadel Jones, Eugene Record, Robert Lester, and Clarence Johnson. Originally called the Hi-Lites, the band had gone through numerous personnel changes over the years, but it always retained its signature smooth vocal sound. It took almost a decade before they scored their first hit record with "Give It Away," followed by a string of hits throughout the 1960s and 1970s. (Robert Pruter.)

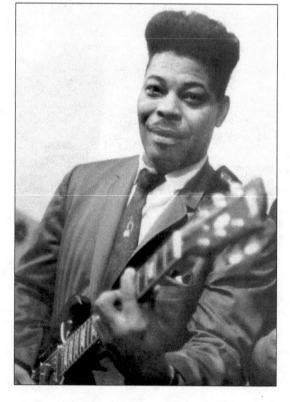

It was a long wait until John Funchess, also known as "John Littlejohn," first put his music on vinyl, but the results were well worth it. After playing his unique style of slide guitar on the Chicago blues circuit since the 1950s, his debut album in 1968 was an homage to the early-1950s style of blues that he grew up with. His playing left an impression on everyone who heard him perform. (Bob Reidy.)

James Ramsey, better known as "Baby Huey," and his band, the Babysitters, became a well-known act on the Chicago 1960s club circuit until Ramsey's death in 1970. Because of his 360-pound size, he chose the nickname Baby Huey after the giant baby duckling cartoon character of the same name. The band recorded several popular single records but never released an album during his lifetime. (Mickey Saxe.)

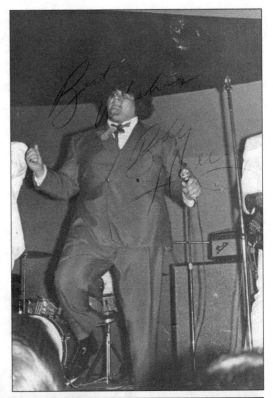

The Siegel Schwall Band is pictured here. From left to right are Russ Chadwick, Jim Schwall, Corky Siegel, and Jack Dawson. Siegel said, "In 1967 we were playing at Chicago clubs and touring all over the place. The band was very popular back then. Even Janis Joplin opened a show for us. In fact, I picked up Janis and her band in my van when they arrived at the airport in Chicago to play Mother Blues." (Corky Siegel.)

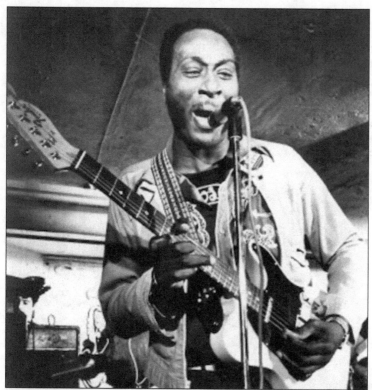

Eddie "the Chief" Clearwater, nicknamed because he is part Cherokee, has covered it all from his early gospel days up to his later blues and eventually rock-and-roll periods. Lauded by *Down Beat* magazine and nominated for a Grammy, Clearwater was a regular on the club circuit throughout the 1960s and 1970s and continues to play today. His heartfelt music appeals to the grittiest south side blues crowd as well as the north side college crowd. (Author's collection.)

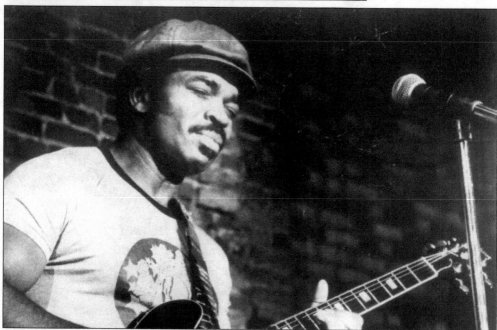

A major influence on rock guitarists Eric Clapton and Jeff Beck, Matt "Guitar" Murphy played with many of the major blues artists of the 1960s and 1970s until eventually forming his own band. Murphy began playing the Chicago circuit with Memphis Slim, and by the 1960s, he had become legendary among guitarists for his fast and intricate blues riffs. (Chicago Public Library.)

The original Paul Butterfield Band might very well be called the first blues supergroup; although its members were not superstars yet, most of them would be in later years. The 1965 lineup of Sam Lay (later replaced by Billy Davenport), Mark Naftalin, Mike Bloomfield, Butterfield, Elvin Bishop, and Jerome Arnold was one of the first interracial bands and included some powerhouse musicians. They almost single-handedly introduced the blues to mainstream white audiences. (Author's collection.)

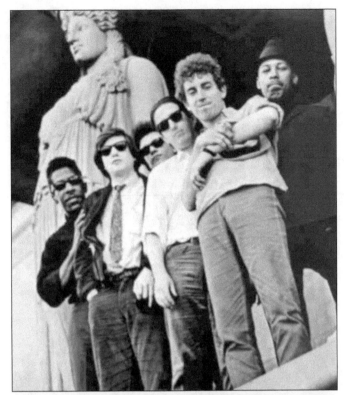

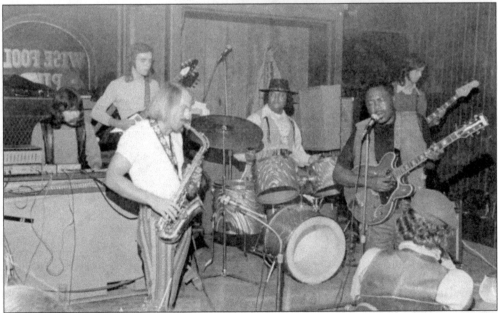

The Bob Reidy Blues Band is one of those bands that can do it all. Not only are they a great band by themselves, but they have been the "go to" band for countless Blues musicians who need solid back up players. Performing on this night with Bob were Sam Lay, Jimmy Rogers, Johnny Young, Frankie Capek, Jim Wydra, Chris Mason and John Littlejohn at Wise Fools Pub. Other core members included Richard Robinson and Bill and Steve Lupkin. (Bob Reidy.)

Walter "Lefty Dizz" Williams was the ultimate showman when it came to giving his audiences a performance they would never forget. But like most showmen, he could also back it up with great musicianship. Williams was a fixture on the club scene during the 1960s and 1970s, with his own band and as a guest with just about everyone in town who wanted to add a little sparkle to their show. (Jim Quattrocki.)

Luther Allison moved to Chicago from Arkansas in 1951 and began hanging around the blues clubs in hopes of being asked onstage to play guitar. Eventually Muddy Waters did invite him up, and from that point on, Allison played the club circuit regularly and went on to steal the show at the Chicago Blues Festival in 1969. He later recorded albums for the Delmark and Motown labels and toured extensively up until his death in 1997. (Chicago Public Library.)

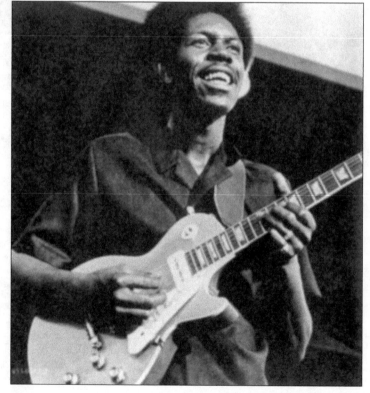

Frank "Son" Seals began performing in his father's club in Arkansas as a teen, and by the time he moved to Chicago in 1971, he was a seasoned blues musician. Discovered by Bruce Iglauer of Alligator Records while he was playing at the Flamingo club on Chicago's south side, Seals recorded several successful albums on that label. (Steve Kagan.)

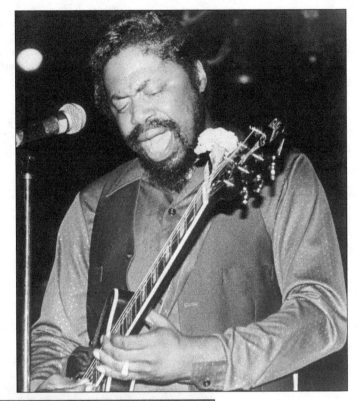

One of the true masters of boogie-woogie and blues piano, Erwin Helfer was already forging his own legacy throughout the 1960s and 1970s, releasing several albums with his partner, Jimmy Walker. A classically trained pianist, Helfer was able to incorporate his skills into a new form of blues piano style that has garnered praise not only in Chicago but around the world. (Chicago Public Library.)

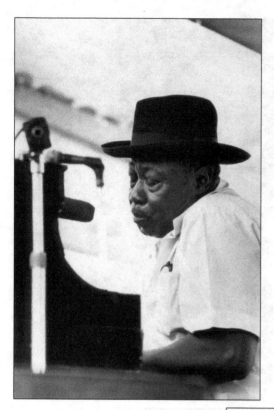

Widely regarded as one of the best blues pianists in the business, Pinetop Perkins's career goes back to 1927, when he began playing in Mississippi. After backing up a number of well-known blues artists, he eventually moved to Chicago and settled in with the Muddy Waters band in 1969. For the next decade, his style contributed immensely to the Muddy Waters sound. (Chicago Public Library.)

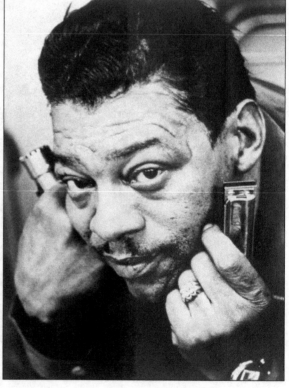

"Play it like little Walter" was probably heard quite a bit on the blues scene over the years. Marion Walter Jacobs was a Creole musician discovered performing on Maxwell Street. His harmonica playing changed the world of blues the way Charlie Parker and Jimi Hendrix forever changed jazz and rock music. Jacobs was described by some as a "defiantly erratic performer," but his influence is still felt today. (Robert Pruter.)

Major Lance moved to Chicago from Mississippi in the 1950s, and his career took off in 1962 when he recorded a string of hit records, one of the most famous having the unlikely title of "Um Um Um Um Um Um." He eventually recorded several hits penned by Curtis Mayfield, but his career went into a slide when he ended up serving a prison term for drug possession. (Robert Pruter.)

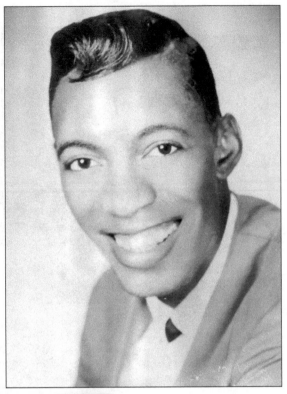

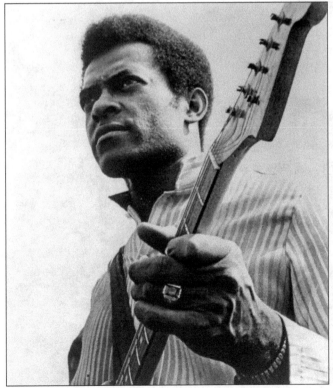

Jimmy Dawkins moved to Chicago in 1955 and began playing the local blues clubs, but it was not until 1969 that his first album *Fast Fingers* was released on the Delmark label. He followed that with a second album in 1971, called "All For Business," and later toured the Midwest with a top-rate band. He eventually formed his own record label and began promoting new artists. (Jim Falconer.)

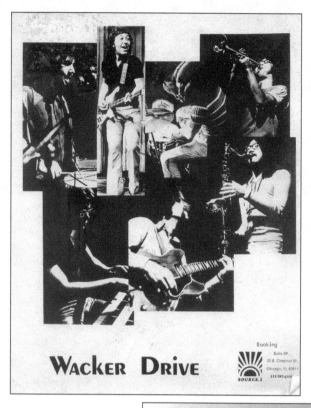

Wacker Drive started out as a soul band—the Soul Union, in fact. But as soul music began to lose favor, the name of the band was changed to something the members felt was a bit more hip. Included in this publicity photograph are Arturo Perez, vocals and percussion; Mario Ingraffia, bass and leader; Tom Schmid, drums; Steve Hashimoto, trumpet; Bob Hashimoto, tenor sax; Jack Froelich, guitar; and Joe Ingraffia, keyboards. (Steve Hashimoto.)

Calling himself "the Blue Shadow," Joe Kelley has been a major part of the Chicago music scene since his days with the Shadows of Knight in the 1960s. After he left the rock-oriented Shadows of Knight, he formed the Joe Kelly Blues band and took his music to the blues. Eddie Clearwater has called him "one of the most energetic and powerful blues guitarists on today's Blues circuit." (Joe Kelley.)

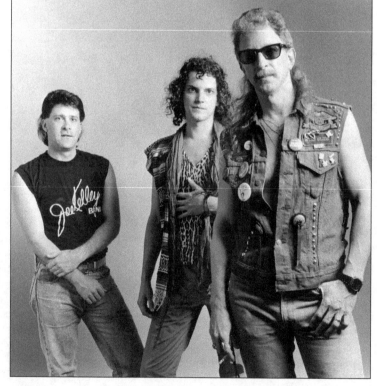

Lou Rawls's early singing career found him alongside high school friend Sam Cooke in a gospel group called the Teenage Kings of Harmony. While touring the South with Cooke in 1958, Rawls was in a near-fatal automobile accident, but within a year, he recovered and was back on stage. The rest of the story is musical history, with sales of more than 40 million records throughout his career. (Guy Arnston.)

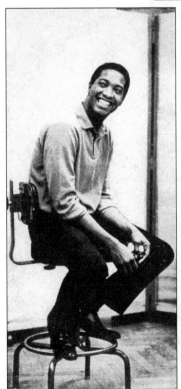

Had he not died a tragic death at the age of 33, there is no telling how many more wonderful songs Cooke would have created. The ones he left behind mark his legacy as one of the best of American singers and a pioneer of soul music. With 29 Top 40 hits between 1957 and 1965, Cooke endeared himself forever to lovers of the blues, rock, and R&B, as well as soul music. (Author's collection.)

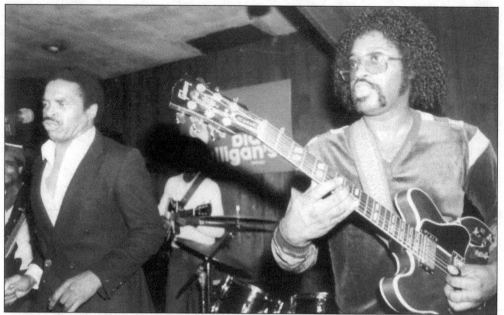

Born in Mississippi, Otis Clay (left) settled in Chicago in 1957 and quickly made the smooth transition from gospel to soul music during the 1960s at a time when Chicago was one of the nation's top soul recording capitals. Clay soon signed with the Chicago-based One-derful record label and over the years had a string of soul and R&B hits for that label. He is pictured here with guitarist Cris Johnson. (Chip Covington.)

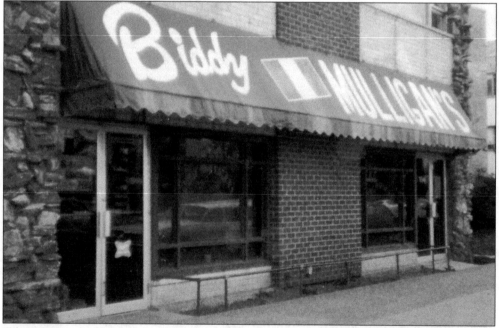

When the north side of the city began to earn a reputation in the 1970s for great new blues clubs, Biddy Mulligans became one of the top rooms in town for the best in blues music. All the major names played there, and because of its comfortable atmosphere and friendly staff, it was a place music lovers came back to on a regular basis. (Chip Covington.)

Three

COUNTRY AND BLUEGRASS

I'm glad to see everybody here showed up!

—Curt Delaney, Chicago musician

Although Chicago had its own country music scene in the early 1960s, it was largely centered in the Loop area of the city and did not really thrive throughout the Chicagoland area until the 1970s, when scores of country music clubs began opening all throughout the city and suburbs, concurrent with the rise in popularity of the genre in general across the United States. Joan Delaney, the widow of Curt Delaney, a well-known Chicago-based musician, remembers that many of the country-and-western music clubs in the West Loop area were considered rough and even violent places. One of the most raucous nightspots was the infamous Tomahawk Club, a venue that was popular with local Native Americans. The music was great, but the clientele liked to party hard, and it was not a hangout for the timid.

However, there was also a more sophisticated circuit of downtown clubs in the Loop area that catered to the weekend "dress up night" crowds. One of the earliest clubs of the genre was the Ringside Ranch (better known in later years as the RR Ranch), which hosted a country trio called the Sundowners as the house band for close to 30 years, surely a record of some sort.

By the 1970s, country music was attracting a new generation of listeners, particularly the younger dance crowd, and throughout the decade, new clubs were opening in the surrounding suburbs. Nashville North, opening in 1975, was probably one of the earliest of the new country dance clubs, and it was also at the forefront of the line dance craze that came on the scene a few years later. Through the end of the 1970s, it was easy to find live country and bluegrass music at any number of clubs surrounding the city on a five- or sometimes six-night-per-week basis. It was a great time to be a country musician since there was plenty of work, and if a player was lucky enough to join one of the house bands in the numerous clubs, one could even make a decent living.

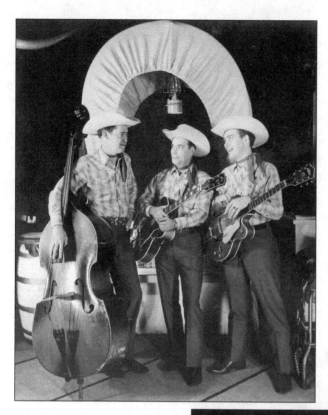

The Sundowners held the record for what is probably the longest-running house band gig in Chicago history. They presided at the RR Ranch for 30 years, entertaining audiences with country and authentic western music. From left to right, Curt Delaney, Bob Boyd, and Don Walls all came to Chicago from the southern states in the 1950s and never looked back. The author performed with them many times as their substitute bass player. (Joan Delaney.)

During the 1960s, as rock and roll grew in popularity, many bands sought to redefine themselves in order to keep up with the new sounds. The Sundowners were no exception, and when they were called upon to play rock music, they simply changed their hairstyles and clothes and became a rock band. Of course, they were all accomplished musicians in many styles, so adapting to the more modern music was an easy transition for them. (Joan Delaney.)

The RR Ranch was *the* place for country music through the 1960s and well into the 1970s, thanks to the house band, the Sundowners. It was not unusual to walk into the basement club and find well-known national stars who had come to visit their friends in the band. Here a couple of the Maines Brothers, including Lloyd Maines, father of Dixie Chicks singer Natalie Maines, join the Sundowners for an informal jam. (Joan Delaney.)

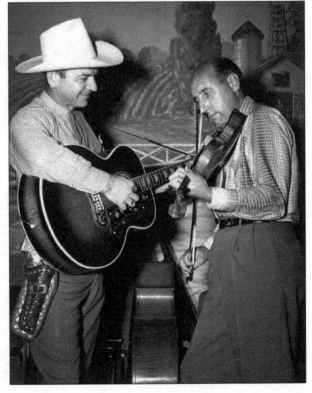

Although many think of Johnny Frigo as a jazz violinist, during his early years of playing, he focused on the bass and was actually very active on the country music scene. In this picture, he is seen with country star Bob Atcher (left) while the two of them perform on the WLS *Barn Dance* show. He could slide easily between jazz and country music and was an excellent player in both genres. (Alfred Ticoalu.)

Archie and Marlene's Nashville North was located in the western suburb of Bensenville and was one of the most popular clubs on the circuit from its opening in 1975 until it closed in the late 1990s. The author played there with several bands over a 20-year period, and he and his wife met on the dance floor. The band playing in this picture is Dave Gibson and Hackinbush. (Author's collection.)

Dave Gibson and his band Hackinbush delighted Chicago audiences throughout the 1970s, primarily as the house band for Nashville North and Spanky's in Willow Springs. Band members over the years included Kirby Bivans, Rick Shryock, Chris Miller, Willie Wainwright, Mike McKean, and Tom Bethke. The author joined the band for one year and was impressed by Gibson's songwriting abilities. Gibson eventually moved to Nashville where he penned hits for many big-name performers. (Angelo Varias/ Kirby Bivans.)

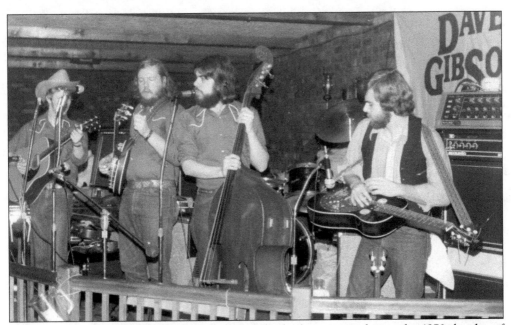

The Scuttlebucket band played the Chicago and suburban circuit during the 1970s heyday of bluegrass. Members were Rick Shryock, Chuck Wahlstrom, Dean Milano, and Jim Bertolin. The band played at neighborhood bars where the crowds could get pretty wild, and they frequently found themselves protecting their instruments from flying objects and falling patrons. They are pictured here performing at Nashville North. (Author's collection.)

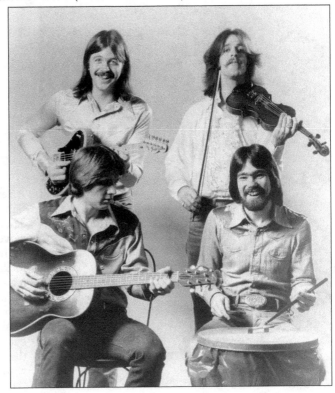

Originally a duo called Bartholemew and Douglas with Ted Douglas on lead guitar and Jim Bartholemew on vocals and rhythm, they added Mike Kieffer on bass and Kirby Bivans on drums and became Cactus Jack. Under the management of Carolyn Bowman, who also managed Rokko and the Hat, the band worked steadily, most notably at Durty Nellies in Palatine and Durty Dicks on the northwest side of Chicago. (Kirby Bivans.)

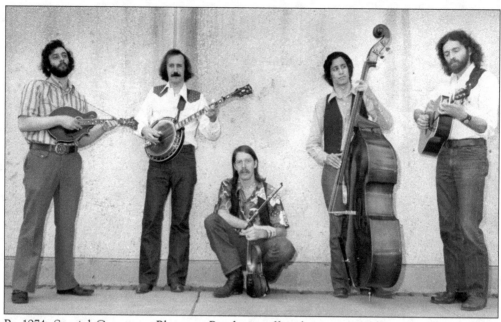

By 1974, Special Consensus Bluegrass Band was off and running as the group that came to define Chicago bluegrass across the nation. Greg Cahill has remained the constant in a band that has featured some of the finest players in the country over the past 35 years. In this original lineup, from left to right, are Jeremy Raven, Cahill, Jim Hale, Mark Edelstein, and Jim Iberg. (Greg Cahill.)

After kicking around Memphis's Sun Studios for a while, Hayden Thompson decided to make the move to Chicago, which became his home in 1958. One of the early rockabilly artists, he continued to record and play the Chicago club circuit as well as the WGN *Barn Dance* radio program. He retired from music in the early 1970s, but a decade later, he rejoined the music world, performing, writing, and recording once again. (Hayden Thompson.)

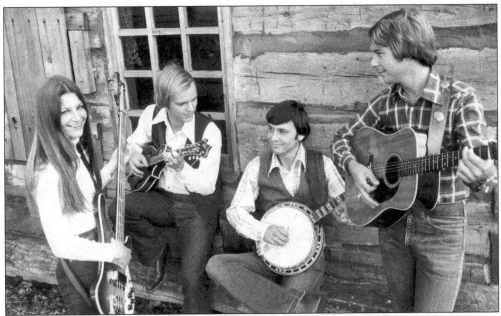

Buck's Stove and Range Company moved to Chicago from south-central Indiana during the bluegrass craze of the 1970s and quickly became one of the top bands on the circuit, performing regularly at the Clearwater Saloon on Lincoln Avenue, among other venues. Members included the brother and sister team of Roger and Denise Banister, Charlie Brown, and Brad Hevron. (Denise [Banister] Kocur.)

Redhouse became the weekend house band at DeWitt's C&C Lounge for a time in the mid-1970s. The band was started by Chris Nordine and bass player Doug Mazique, who was killed a few years later in a robbery attempt. The band also featured Farah Coleman, who went on to lead several of her own bands, and Kirby Bivans, who later played with many of Chicago's top bands. (Kirby Bivans.)

Freewheel was the house band for many years at an inner-city club called Mr. Kileys. Many players rotated through the band during its time there, although Chris Mitchell and Janice Horst were there from beginning to end. Other players, some of whom migrated over from the band Baraboo, included Jerry Lee Davidson, Steve Levitt, Brian Barrett, Nick Sanabria, J. B. Smith, Ivan Strunin, Cary Donham, Curtis Moore, Mitch Alvarez, David Miller, and Bill Taylor. (Janice Horst.)

One of Chicago's more popular country bands during the 1970s was Country Love, featuring Rick Crenshaw, Donita Fay, John Crenshaw, Little Joe Chisler, and Catfish John. The precursor to the Midnight Special band, Country Love not only played the Chicago club circuit, but they also lent their talents as a backup band to many local singers interested in making demo tapes in the various area recording studios. (Donita Crenshaw.)

The Wildwood Pickers was a bluegrass band consisting mainly of women. In the early days of the band, one of those women was Muriel Anderson, who eventually became world famous as a virtuoso guitarist. The author remembers Anderson as "that little kid who used to come to our Bluegrass music picnics and played a mean guitar." Band members pictured are Kathy Jones, Scott Salek, Anderson, Robin Bachor, and Kim Koskela. (Muriel Anderson.)

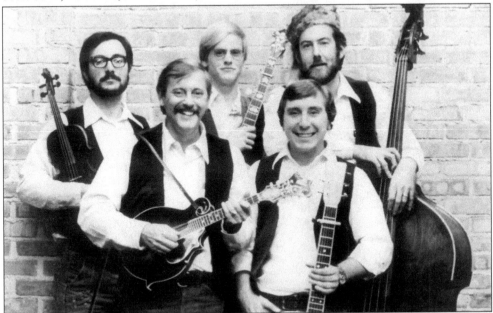

Originally formed by Chuck Kling and Richard Hood in 1973, the Greater Chicago Bluegrass Band recorded two albums and was considered one of the top traditional bluegrass bands in the Midwest. Other members included Mose Hood, Rex Waters, Mark Clark, Greg Trafidlo, Jeff Krause, Roger Bellow, and Scott Keiffer. The author served as a substitute bass player for the band on several occasions. (Greg Trafidlo.)

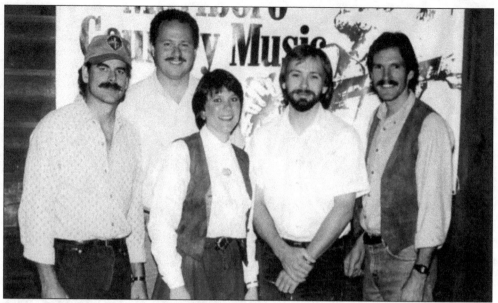

Drew and Liz Carson played folk in the band Crazy Creek, bluegrass in the band Weeds of Bluegrass, and country music in the Silver Dollar Band during their years on the Chicago scene. In the 1970s, the Silver Dollar Band consisted of the Carsons, Barry Capaul, Jeff Keene, and Jim Corsolini. The couple eventually ended up at Nashville North in Bensenville as part of Coyote Moon, another band that the author frequently worked in as a substitute bassist. (Drew Carson.)

Bonnie Ferguson was a popular singer in the Chicago area during the late 1960s and into the 1970s. She had her own band and was seen on the *Barn Dance* television program and eventually signed with Ovation Records. She was also a noted jingle singer, known especially for the *Chicago Tribune* radio commercials she sang and the "Friendly Skies of United," one of her most famous. (Donita Crenshaw.)

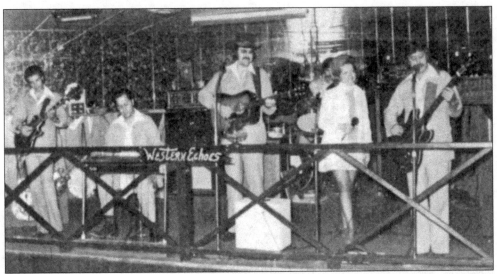

The Western Echoes, under the leadership of guitarist Gary Brock, was the house band for several of the Chicago area country-and-western clubs, among them the Country Music Inn and later Nashville North, where they presided until they disbanded and were replaced by Coyote Moon. This photograph was taken at the Country Music Inn, and band members at this time, from left to right, are Stanley Barnett, Jim Shepherd, Brock, Kirby Bivans, Libby Shepherd, and Ernie Green. (Kirby Bivans.)

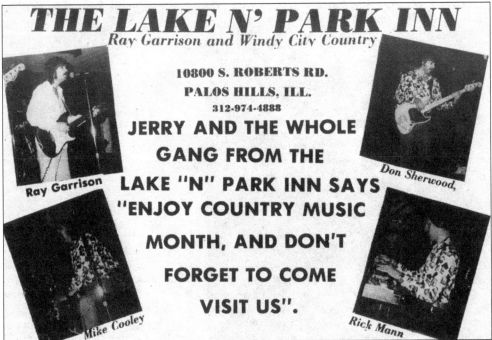

Ray Garrison and Windy City Country spent a good deal of the 1970s as the house band for the Lake 'n Park Inn in suburban Palos Hills. They were well established at that venue, and it was reflected in the folksy advertisements the owner took out in the various local papers. Members during this time were Garrison, Don Sherwood, Mike Cooley, and Rick Mann. (Donita Crenshaw.)

Named one of the country's best unsigned bands by the *Playboy* magazine readers poll of 1977, Ouray was one of Chicago's more popular country rock bands. The band had a regular Tuesday night spot at Ratsos for several years, and they eventually did get signed, producing two albums. Band members included Bo Pirruccello, Tom Peters, Hap Harriman, Frank Pirruccello, and Ted Rawlings. (Bo Pirruccello.)

Formed in 1973 as a folk and jug band music act called Unity, the band changed its name to the Unity Bluegrass Band in 1976. They became a top Chicago club band and toured the Midwest and western states for the rest of the decade. Band members included Doug Minard, David Neidig, and David Bragman, among others. (Adrian McKee.)

Mark Zeus, Bob Abplanalp, and Tom O'Brien found themselves making music together at the Let It Be Lounge on an informal basis, and before they knew it, they were a band. They called themselves Tumble Weed and hit the Chicago country rock club scene. Over the next few years, they went from a trio to a five-piece band and became a featured Chicagofest act three years in a row. (Mark Zeus.)

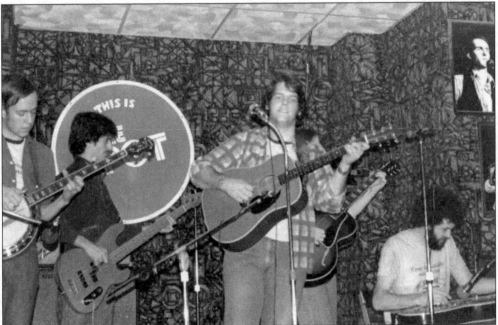

The Spot was a pizzeria in Evanston that featured live acoustic music every weekend and became a regular place to play for many folk musicians. The crowds tended to get a bit loud, but some folks actually listened and enjoyed the music. Gracing the fully carpeted stage on this occasion are Peter Nye, Mike Sweeney, Evan Howes, John Landsford, and Stephanie Austin. (Peter Nye.)

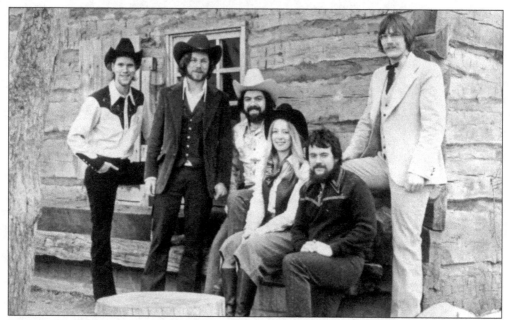

Jump 'n the Saddle was one of the more popular bands on the Chicago club circuit even before their single "The Curley Shuffle" hit the airwaves. Their unique brand of country novelty tunes and western swing music coupled with great musicianship was a formula for success. Band members included Peter Quinn, Tommy Furlong, Dave Roberts, and the husband-and-wife team of Annie and Barney Schwartz. (Tom Furlong.)

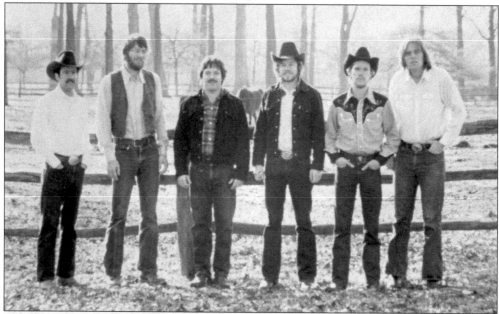

Rio Grande covered traditional country as well as original music. When asked to fill in for the house band at a Chicago honky-tonk bar, the club owner inquired if the band had matching uniforms. When the band members arrived dressed differently on the first night, the club owner questioned, "I thought you said you had matching uniforms?" And their reply was, "We do but we don't all wear them on the same day." (Tommy Furlong.)

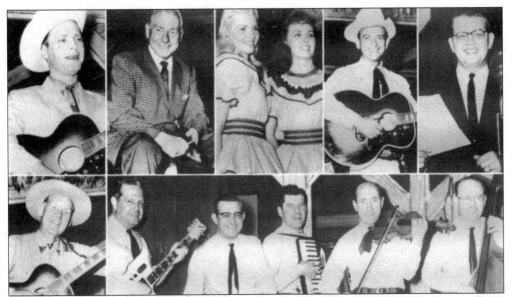

The WLS *Barn Dance* was still a thriving radio show into the 1960s when it moved to its new home at WGN. The show featured many Chicago country artists. Seen in this collage from left to right are (top row) Dolph Hewitt, Red Blanchard, Ruth and Edith Johnson, Bob Atcher, and Orion Samuelson; (bottom row) Arkie, Jim Hutchinson, Tim Murphy, Lino Frigo, Johnny Frigo, and Toby Nix. (Alfred Ticoalu.)

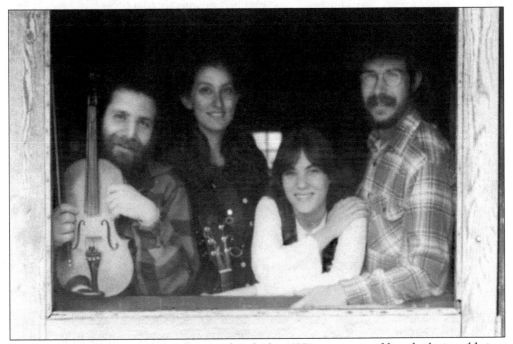

The Chicago Barn Dance Company started in the late 1970s as a group of friends playing old-time Appalachian-style music with the goal of keeping traditional barn dance music alive. The core band of Mark Gunther, Mark Ritchie, and Kathy Hirsh supplied the music for dances that were taught and led by caller and flatfoot buckdance clogger Masha Goodman. (Masha Goodman.)

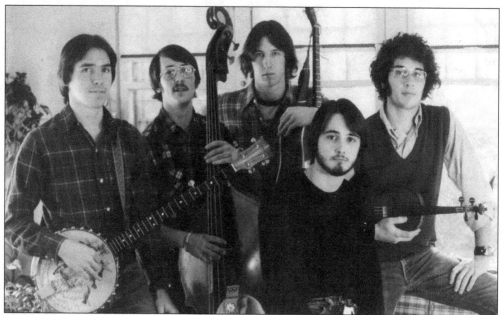

Cornblight was a five-piece string band that played folk-rock, bluegrass, and originals. They moved into Chicago in the fall of 1977 and stayed through the spring of 1978, playing at the Bulls, the Iron Rail, Single File, Old Town School, and others. An audience favorite was their acappella original composition, "Voo Vah Vuh Doo." Band members were Michael Miles, Dane Bonecutter, Bob Lyons, Ross Thompson, and Phil Rosenburg. (Michael Miles.)

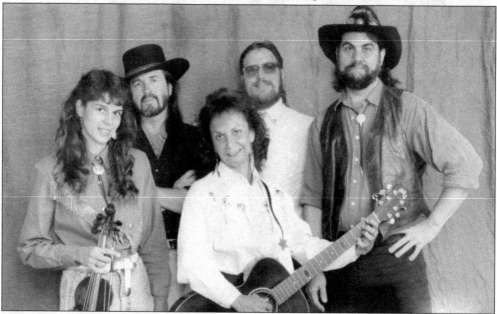

Dennis Cahill has continued to win accolades around the world as one of the top Irish guitarists in the genre today, and his hometown of Chicago is deservedly proud of him. But before his Irish days, he was a regular on the Chicago folk and country music scene. He is pictured here with the band Tumbleweed Junction. From left to right are Lida Bringe, Dennis Cahill, Karen Dale, Rich Kreegier, and Dean Milano. (Author's collection.)

Four

JAZZ AND BIG BAND

I know you can play; just don't do it on my gig!

—Bandleader Stanley Paul advising new members joining his band

Chicago has a rich history of jazz going back to the 1920s. By the late 1950s, it had become one of the predominant forms of music on the club circuit, due in part to the popularity of jazz themes used in many television shows. The most well known was *Peter Gunn*, a weekly detective series that opened with a driving and wild theme song that set the tone for the show. In many episodes, the star of the show hung out in a jazz nightclub, and the connection was inevitable—hang out in a jazz nightclub, and one could be as cool as Gunn himself.

The Chicago Uptown area was the location of the more well-known clubs in the early 1960s, including A&L Turk, the French Poodle, the Plugged Nickel, and of course the Jazz Showcase. The music styles were divided between the "cool school" and the "hardcores," among others, and many clubs were packed five nights a week.

By the early 1970s, as rock and finally disco became more popular, young women began migrating to the discos and rock clubs, and the young men followed.

Bob Centano, leader of several jazz big bands during those decades, agrees that there was an obvious change from the 1960s to the end of the 1970s: "The rooms got smaller and so did the crowds. Another indication was a lack of maintenance on the club owners' part regarding care of the house pianos, an essential instrument in most jazz bands. The owners let the pianos depreciate and sometimes the pianos disappeared altogether." "We went back to the Pump Room for a return engagement and complained to the owners that the piano still had not been repaired since the last time we played there." The owner told Centano, "But we did fix it up. Didn't you notice we painted it?" Ira Sullivan concurs, "When we played some of the smaller clubs, if 43 of the 88 keys on the piano worked, we considered ourselves lucky!"

As with all live music, times have been tough for jazz, but like any great genre, there will always be enough fans to keep it alive throughout the worst of times. Jazz continues to be played in Chicago and its suburbs, and once found, the music never fails to deliver, and the search is always worth the gold at the end of the rainbow.

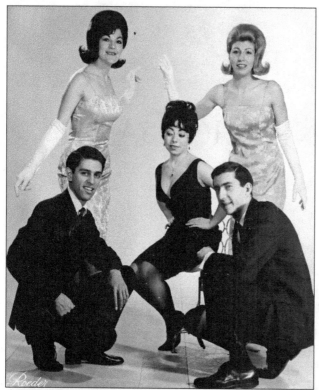

Their official name was the Centano-Ojeda Review, featuring Josie Falbo and the Smart Sisters. Bob Centano and Bobby Ojeda were two of Chicago's top jazz players, and Falbo was one of the best singers on the circuit. But who are the Smart Sisters? Centano said, "Oh, they were just two good looking women we met at the resort we were playing, so we asked them to join us in the picture." (Bob Centano.)

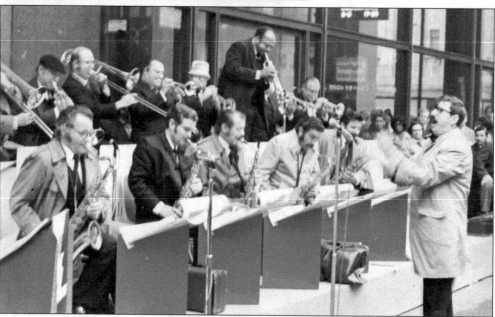

When one thinks of jazz big bands in Chicago, the name Bob Centano always comes to mind. In this photograph, his 1968 band performs at the Daley Center. Centano is conducting, and among the band members are some of Chicago's finest players. From left to right (first row) Joe Daley, Tony Dalesandro, Lenny Druss, Rich Fudoli, and Ron Kolber; (second row) Cy Touff, Loren Binford, John Howell, George Bean, Art Hoyle, and Ed Shedowsky. (Bob Centano.)

74

Legendary horn player Ira Sullivan began his long career in Chicago. "We'd play the Spotlight Club at Belmont and Broadway for a few weeks til the owner kicked us out," he recalls, "Then we'd move across the street to the Character Club until they kicked us out so we'd move back to the Spotlight again. The fans knew if they couldn't find us at the one club, they could walk across the street and find us there!" (Bill Klewitz.)

John Klemmer introduced his unique saxophone sound to Chicago in the 1960s and is probably one of the pioneers of the jazz/rock fusion sound that became popular in the 1970s. But he did not stop there, as his new nickname became "the Ambassador of Cool," owing to the later style he developed that many attribute to the more current smooth jazz sound so common today. (Guy Arnston.)

The author's uncle Conti Milano was a fixture on the Chicago jazz scene in the early 1960s and was responsible for getting many local musicians their start on the Chicago club circuit. He was an outstanding bassist and played with many of the greats, including Charlie Parker, Miles Davis, Oscar Peterson, and Nat King Cole, to name a few. He might even be the reason the author became a bass player. (Author's collection.)

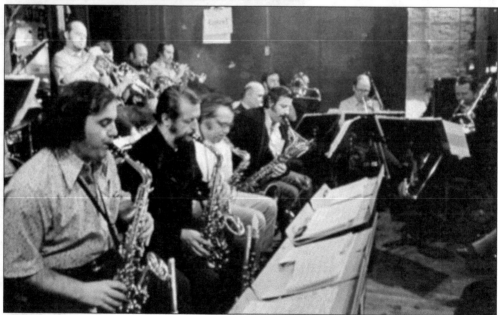

The Wise Fools Pub was known for its esoteric mix of live music styles, big band jazz being among them. One of the favorite regular groups was the Dave Remington Big Band. This 1968 photograph features George Bean, Bobby Lewis, Art Hoyle, and Russ Iverson on trumpets; Cy Touff, John Haynor, Loren Binford, and Dave Remington on trombones; and Rich Corpolongo, Len Druss, Joe Daley, and Ron Kolber on saxophones. (Steve Kolber.)

Frank D'Rone came to Chicago from New York when he landed a gig at Dante's Inferno, a Chicago nightclub. It was the beginning of a successful career during which Nat King Cole and Frank Sinatra were among his many fans. Over the years, D'Rone played every major venue in the country, including repeat appearances on *The Tonight Show*, but he always came home to Chicago, where he still performs today. (Frank D'Rone.)

Buddy Charles could probably be called Chicago's "king of the house gigs" after 10 years at the Coq d'Or and 18 years at the Acorn, both of which were in the Rush Street area. He played the songs of the great bygone eras, and he was seldom stumped on a song request. Mike Royko referred to the Acorn as "one of the best gin mills in Chicago" because of Charles. (Chicago Public Library.)

Ahmad Jamal was known to play the piano with such gusto that it frequently required tuning between sets on his performances. His style of extended soloing was said to be a major influence on Miles Davis's early work. Thanks to the success of his classic version of "Poinciana" from his debut album, Jamal was able to open a restaurant and nightclub in Chicago called the Alhambra, which hosted great jazz for many years. (Chicago Public Library.)

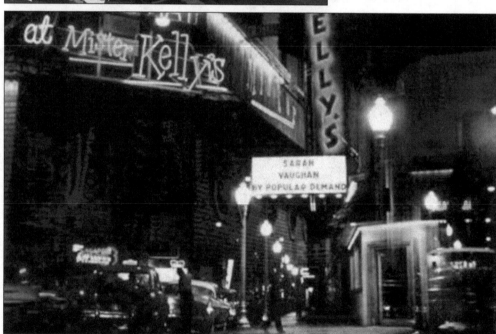

Mister Kelly's was probably one of the most famous nightspots in the Rush Street area. It offered a cozy atmosphere and perfect acoustics, and as a result, many live albums were recorded there by some major national acts. There was also room for local acts on the bill, however, and a spot on Mister Kelly's stage was coveted by many a Chicago player. (Author's collection.)

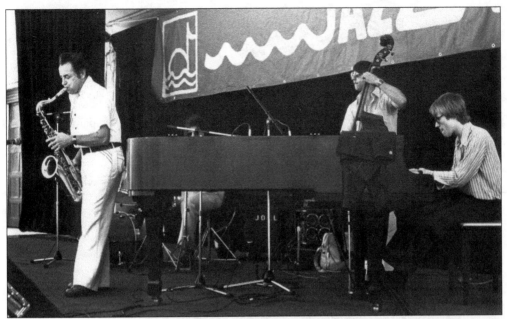

After serving in World War II, saxophonist Joe Daley came to Chicago ready to play jazz. His influences were many, but he soon developed his own style and eventually worked with many well-known players and singers of the day. Daley said, "I did about 30 sides for Pat Boone . . . I played a lot of solos but they wouldn't let me blow. They would say, 'You're playing too good, man.'" (Guy Arnston.)

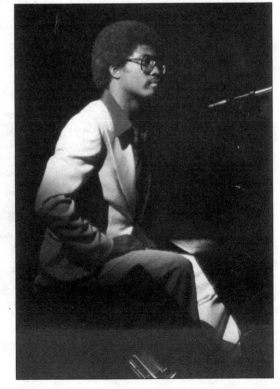

Herbie Hancock has always been tough to define- is he a Rock, Soul or Jazz player? He's one of those few musicians who can easily be labeled with multiple styles. He actually performed a classical piano piece with the Chicago Symphony at age 11, but by his teens he was leaning towards more popular music and within a few years, he was already becoming immersed in Jazz. (Guy Arnston.)

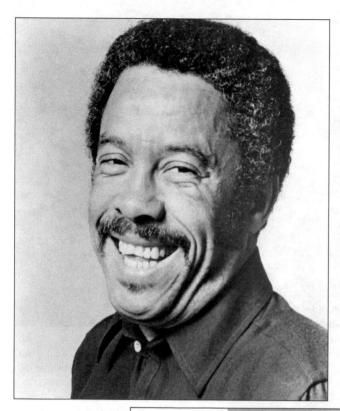

By the time he graduated from Chicago's DuSable High School, saxaphonist Johnny Griffin was already doing time in bands led by T-Bone Walker and Lionel Hampton. He continued to move up in the ranks as a top player, and by 1960, he had formed his own band with Eddie "Lockjaw" Davis, playing the Chicago club circuit and recording several albums together. (Chicago Public Library.)

Chicago was home to one of the busiest commercial jingle scenes in the country, cranking out enough radio and television spots to keep a decent number of musicians busy. Included in this picture of the Jingle-Aires from 1965 are Warren Kime, who also led the Brass Impact Band; Dick Judson, famous for the big band he had in Chicago for many years; Loren Binford; Joanne Judson; and Donna Kime. (Loren Binford.)

If you're looking for a new sound call...

The Jingle-Aires

Barrett Deems certainly earned his nickname "Speed Demon, the world's fastest drummer." He was not only a great drummer, but at times he could be the whole show with his lighted drums and wild antics. He played with all the big names over the years and also led his own band. (Author's collection.)

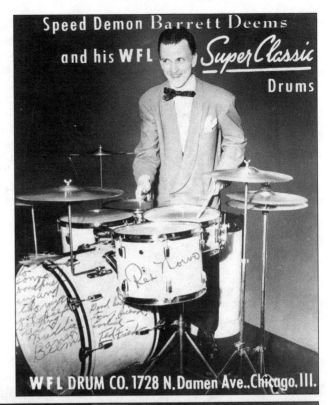

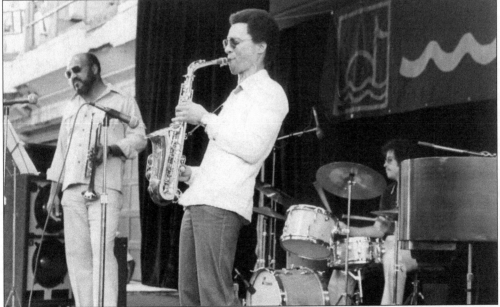

Raised in Milwaukee, Bunky Green came to Chicago with his saxophone in the early 1960s and made the city his musical home. Green said, "I followed in the footsteps of Connie Milano and Willie Pickens, the renowned pianist from Milwaukee that Connie brought to Chicago with him." Green eventually played and recorded with virtually every major jazz player in the business. Here he shares the stage with trumpeter Art Hoyle (left). (Guy Arnston.)

Burton and Ruth Marion Tobias became staples of the Chicago music scene after meeting on a jobbing date and eventually marrying. The couple worked as studio musicians and performers in many premier Chicago bands. Burt played the trumpet, and Ruth sang and eventually studied the double bass, playing with her own group, Ruth Marion and Her Escorts. She said, "There were so many venues and so much work in the 1960s and '70s!" (Ruth Tobias.)

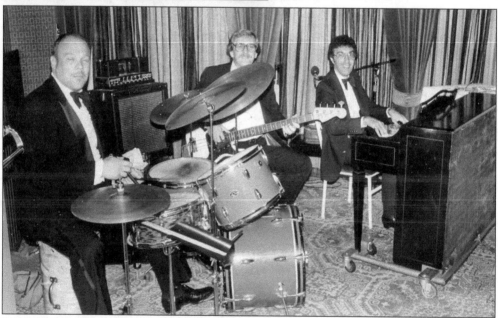

Danny Long, a Chicago jazz pianist, has always been known for the high caliber of players used in his trio. Nick Schneider played bass with Long for 11 years, and former George Shearing drummer Rusty Jones played with the trio on many gigs in the 1970s. This 1976 photograph is from a private party during their days as the house trio at the Ritz-Carlton Hotel at Water Tower Place. (Peter Longo.)

Bob Dogan is considered one of the great unsung artists and a mentor to many younger Chicago musicians and singers in the 1970s. He was a composer of hundreds of songs and played piano with the Buddy Rich band for a time. Jeannie Lambert said, "Bob Dogan was truly a Chicago treasure." (Bill Klewitz.)

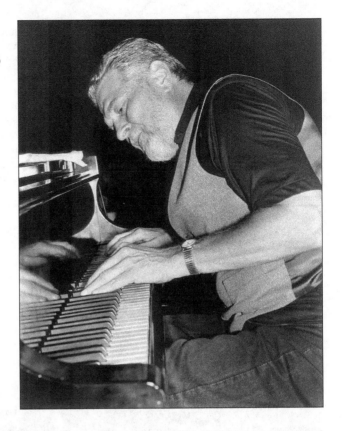

Here is a great selection of small club advertisements from the *Spotlight* newsletter, a monthly guide put out by the Le Bistro club. The club owners were obviously confident enough in their business that they actually allowed competing clubs to advertise in their own newsletter. At this time, there was an almost unlimited number of clubs in the Loop area hosting live music. These particular advertisements are from October 1962. (Author's collection.)

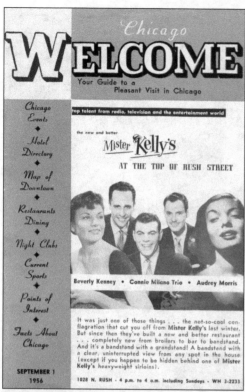

Weekly guidebooks, such as *Welcome Chicago*, were an easy means of finding live entertainment of every type in Chicago. Available in most major cities across the country, these magazines featured information on nightclubs, as well as the musicians and bands performing in town that week. This particular issue features Conti Milano and his trio on the cover along with Chicago jazz singer Audrey Morris. (Author's collection.)

Jazz of All Eras, better known as Ears, was one of the most popular jazz aggregations on the Chicago scene for many years, particularly through its regular shows at Orphans and Andy's. The band was fronted by Bobby Lewis and Cy Touff and boasted many of Chicago's top players. Pictured here are (first row) George Bean, Dick Borden, and Don Shelton; (second row) Touff, Dick Reynolds, John Whitfield, and Lewis. (Bobby Lewis.)

Airflow Deluxe (named by the author for one of his favorite old cars) was formed from two Chicago bands, the Casualaires and the Ezra Quantine Ragtime Memorial Band. The dream was to blend the smooth four-part harmonies of the Casualaires with the big-band sound of Ezra Quantine. The ensemble proved to be too cumbersome, and it soon became obvious that the experiment had basically become a money pit. (Author's collection.)

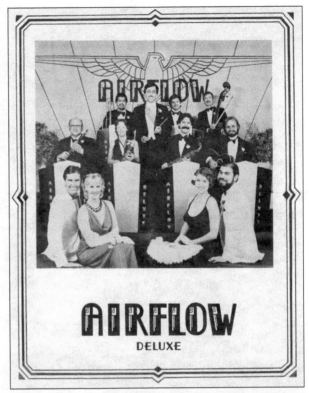

When the author started to become familiar with the Chicago jobbing scene in the early 1970s, Joe Iaco was kind enough to sneak him into the Playboy club, of which he was the music director, for several wonderful music events. He also helped with connections to start many other young musicians on their jobbing careers. This photograph of the Joe Iaco trio, taken at Blondies, features (from left to right) Chuck Christiansen, Ernie Outlaw, and Iaco. (Chuck Christiansen.)

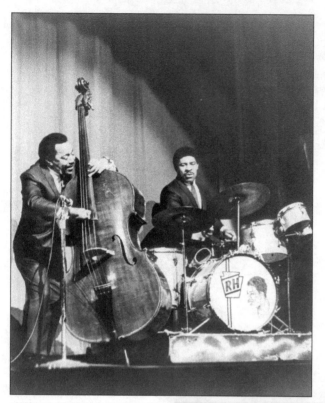

Eldee Young was a jazz double-bass player whose styles included cool jazz, bop, and R&B. In 1965, after 10 years with the Ramsey Lewis Trio, he formed the Young-Holt Unlimited trio with Isaac "Red" Holt. A decade later, the band split up, and Young eventually returned to the Ramsey Lewis Trio. In the interim, he also played with Jeremy Monteiro for over 20 years. (Tyree Young.)

Referred to as "the great performer," Ramsey Lewis has recorded over 80 albums, combining his love of jazz, classical, and gospel music into his own unique style. His original trio consisted of Isaac Holt and Eldee Young, and they were probably best known for their 1965 hit record "The In Crowd." Leaning more toward a rock sound, the song has become a standard in the American music catalog. (Chicago Public Library.)

The Honeyhuggers were supposed to be a showband, but the level of talent among the players put them into the realm of a legit Jazz group. Members were (left to right) Larry Markwell, Jeannie Lambert, John Warner, Linda Holmes, and Tommy Ponce, . Linda- "One night a somewhat shady club owner suggested we take our equipment home early, so we loaded everything up. An hour later, the club blew up and burned to the ground." (John Warner.)

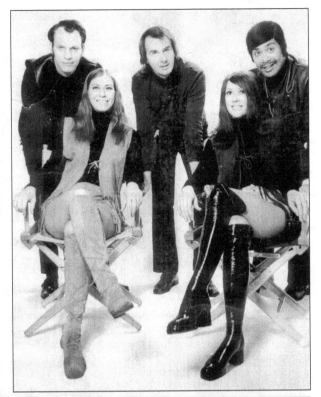

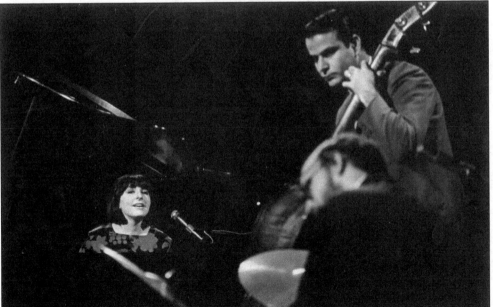

The *Chicago Tribune* once called Judy Roberts "Chicago's Favorite Jazz Woman," and it was a well-deserved title. With over 20 albums to her credit, Roberts made her mark on Chicago and the world throughout her career. And of course, it did not hurt that she surrounded herself with some of the best sidemen in the business, including Nick Tountas on bass and George Marsh on drums, both pictured here. (Nick Tountas.)

A great moment in Chicago jazz history was the night saxophone icon Eddie Harris performed with the John Campbell Trio at the renowned Jazz Showcase in 1979. At this time, the trio had begun to receive national acclaim as the rhythm section of choice when it came to accompanying world-class jazz artists. Pictured here (from left to right) are John Campbell, Eddie Harris, Joel Spencer, and Kelly Sill. (Bill Klewitz.)

Founded by Alejo Poveda in the 1970s as a percussion ensemble, Chévere morphed into Chicago's leading Latin/jazz/funk/blues band, mixing Afro-Cuban, Brazilian, jazz, and blues into an exciting and unique collage of sound. Characterized by high-voltage percussion and original compositions, Chévere has performed around Chicago and the Midwest for over 30 years. This picture was taken during the band's performance at Jazz Oasis on Chicago's Navy Pier. (Steve Eisen.)

Playing every type of jazz from Dixieland to modern, Eddie Higgins worked the Chicago club scene in the 1960s and became well known for his 12-year house gig at the London House. Besides live performance, Higgins was also a founder of Dunwich Records, an important Chicago label. He is pictured here with Richard Evan (center) and Marshall Thompson (right) at the London House in 1961. (Meredith Higgins.)

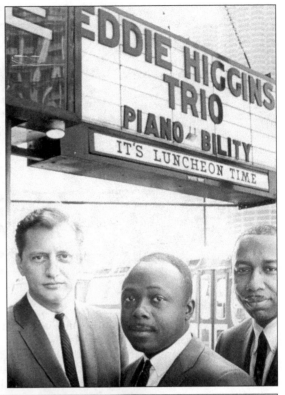

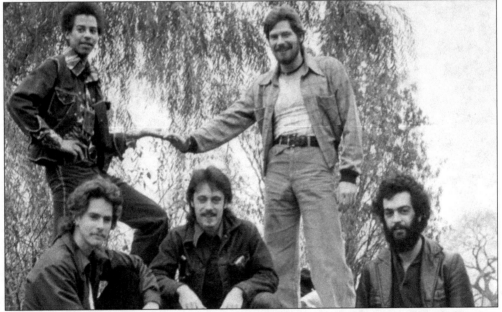

Orbit was a jazz-fusion group featuring several well-known Chicago musicians, including Eric Hochberg, Ross Traut, Steve Eisen, Andy Potter, and Ken Elliot. The band rotated for several years between clubs such as the Bulls, Wise Fools, and Ratsos. Hochberg said, "Orbit did original music written by Ross and myself. We recorded an album produced by Bill Traut but unfortunately, it was never released." (Eric Hochberg.)

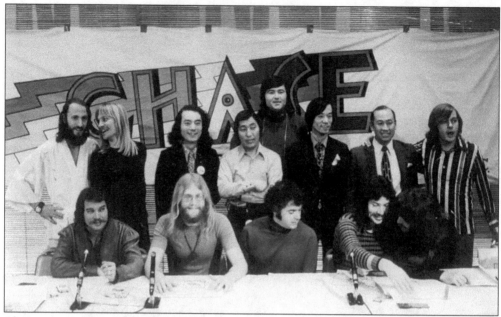

Chase, the "Get It On" Grammy-nominated jazz/rock band, was comprised of leader Bill Chase, Ted Piercefield, Alan Ware, Jerry Van Blair, Terry Richards, Angel South, Jay Burrid, Phil Porter, and Dennis Johnson. On the *Ennea* album, Gary Smith and G. G. Shinn, pictured here in Japan, replaced Burrid and Richards. Chase and four other members from their last album, *Pure Music*, died in a tragic airplane crash in 1974. (Gary Smith.)

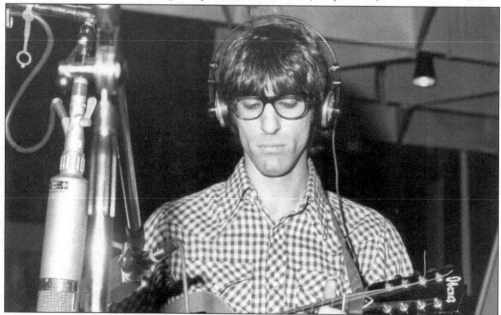

One night at the Bulls in 1977, the author was approached by a harmonica player who asked to sit in with his band. He agreed, even though he did not recognize the musician. After one song was played, he stepped back and asked, "Who is this guy?" Howard Levy has been astounding audiences ever since with his harmonica playing, most notably as a founding member of Bela Fleck and the Flecktones. (Author's collection.)

Fantasie was a progressive jazz-fusion band in the Mahavishnu mode, which existed from about 1974 to 1979. Bassist Doug Lofstrom said, "Most of that time we spent writing, jamming and rehearsing in my basement in the Austin neighborhood. After 1977, we played at Collette's, Kingston Mines and Wise Fools, as well as a lot of the outdoor festivals." Members included Jim Teister, Doug Lofstrom, Ruben DeAndrea, Rick Panzer, and Glenn Charvat. (Doug Lofstrom.)

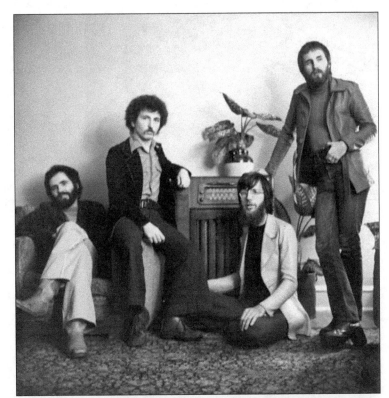

Eddie Piccard started playing with his trio in 1969 at Meo's Norwood House in Chicago and eventually went on to play the Happy Medium, the London House, the Four Torches, the Back Room, and many other well-known venues. Piccard said, "I was known for my spot on impression of Ray Charles!" His players were always top-notch, and members in this picture include John Bany (left) and Jimmy Fetter (right). (Eddie Piccard.)

Faith Pillow enlivened the stages of many Chicago venues during the 1970s with her polished musicianship and powerful personality. A Louisville native, she made Chicago her own. She was an accomplished songwriter, performing mostly her own work, and her style was perfect for intimate, smoky bars like the Bulls, where she often appeared. Her first album was a well-received live effort recorded at Orphans nightclub. (Paul O'Brien.)

Streetdancer is a jazz-fusion band that formed in 1974 and, due to their unique sound, were quickly signed with Dharma Records, a Chicago label. Three albums were recorded, and various members over the years included Chico Freeman, Ari Brown, Steve Eisen, Kenny Elliot, Henry Threadgill, Alejo Poveda, and John Scofield. The 1978 version of the band pictured here includes (from left to right) Andy Potter, leader Kestutis Stanciauskas, and Robert Long. (Kestutis Stanciauskas.)

Five

ROCK, POP, AND SHOW BANDS

What a great crowd we have here tonight! How many kids here from Villa Park?

—Almost any radio deejay at any local 1960s rock show

The Chicago rock scene simply exploded along with the rest of the country during the 1960s. Rock-and-roll music was still coming of age during the early part of the decade, but by the mid-1960s, it was going full steam, and there were amateur rock bands in every garage on every block of the city and its surrounding suburbs. Quite a few of those garage bands actually made some decent noise, developing a style that blended a rock sound with a horn section that was unique to Chicago. When the local record labels, such as Dunwich and Mercury, took notice and started signing bands, a number of them eventually garnered national attention on the radio charts across the country.

The late 1960s saw a shift from the established rock-and-roll sound into the psychedelic era, and many of the well-known Chicago area bands were left behind, unable to adapt to the new style of music. Eventually a new wave of bands came onto the scene, keeping the Chicago sound in tune with the rest of the country.

As the rock scene grew, so did the club scene. Soon the city was dotted with clubs, and every suburb had a rock or a nonalcoholic teen club or youth center. By the early 1970s, the teenage youth clubs were on the wane and all but disappeared, leaving the bar scene to flourish. Many of the clubs featured live bands five nights a week, with music blaring late into the evening, much to the chagrin of some local residents.

The disco sound of the mid-1970s hurt the live music scene in some ways since, for the most part, it did not require live bands, and many of the clubs switched over to deejays and recorded music. But the bands persevered and eventually live music triumphed over the deejays, ushering in the punk rock and new wave sounds, both of which were smoldering reactions to the slick, commercial sounds of disco.

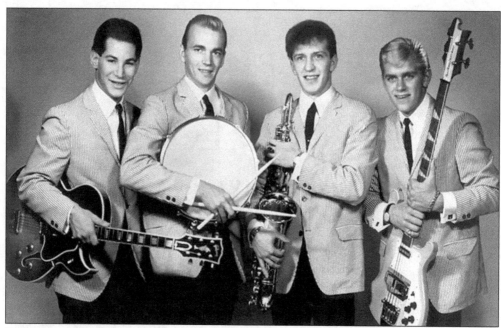

The original band the Exceptions (above) consisted of Kal David, Denny Ebert, Marty Grebb, and Peter Cetera. Eventually David left to join the Rovin' Kind (Illinois Speed Press) and was replaced by James Vincent. Ebert left next and was replaced by Billy Herman. Then Grebb left to join the Buckinghams and was replaced by Jimmy Nyeholt, leaving Cetera the only original member. Musical differences developed when the band decided to quit playing cover material and write their own music, but Cetera was against this and was eventually asked to leave. He was replaced by Bobby Jones, and the band was renamed Aorta. A few months later, Vincent suggested to his friend Terry Kath that they try Cetera for his band, Chicago Transit Authority. The band hired him, shortened its name to Chicago, and the rest is history. (Mac Macoy/ HK Productions.)

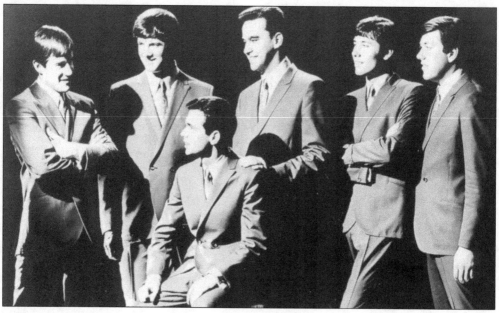

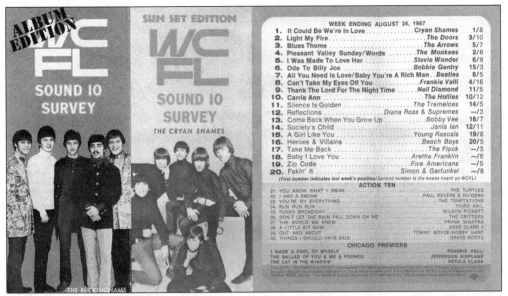

WCFL, a popular rock-and-roll radio station during the 1960s and 1970s, issued weekly surveys for its Top 40 music listeners. It rarely pictured local bands on the cover, but these two featured the Cryan' Shames and the Buckinghams, Chicago bands that had broken into the national scene with several hit singles. (Author's collection/Marlene O'Malley.)

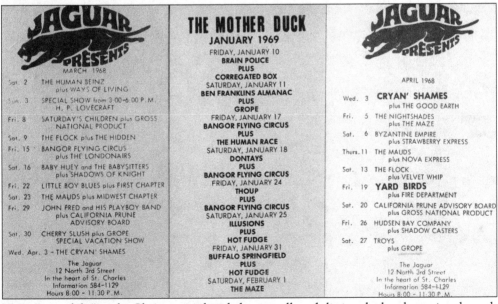

JAGUAR PRESENTS

MARCH 1968

Sat. 2	THE HUMAN BEINZ	plus WAYS OF LIVING
Sun. 3	SPECIAL SHOW from 3:00-6:00 P.M.	H. P. LOVECRAFT
Fri. 8	SATURDAY'S CHILDREN plus GROSS	NATIONAL PRODUCT
Sat. 9	THE FLOCK plus THE HIDDEN	
Fri. 15	BANGOR FLYING CIRCUS	plus THE LONDONAIRS
Sat. 16	BABY HUEY and THE BABYSITTERS	plus SHADOWS OF KNIGHT
Fri. 22	LITTLE BOY BLUES plus FIRST CHAPTER	
Sat. 23	THE MAUDS plus MIDWEST CHAPTER	
Fri. 29	JOHN FRED and HIS PLAYBOY BAND	plus CALIFORNIA PRUNE ADVISORY BOARD
Sat. 30	CHERRY SLUSH plus GROPE	SPECIAL VACATION SHOW
Wed. Apr. 3	THE CRYAN' SHAMES	

The Jaguar
12 North 3rd Street
In the heart of St. Charles
Information 584-1129
Hours 8:00 - 11:30 P.M.

THE MOTHER DUCK

JANUARY 1969

FRIDAY, JANUARY 10
BRAIN POLICE
PLUS
CORREGATED BOX
SATURDAY, JANUARY 11
BEN FRANKLINS ALMANAC
PLUS
GROPE
FRIDAY, JANUARY 17
BANGOR FLYING CIRCUS
PLUS
THE HUMAN RACE
SATURDAY, JANUARY 18
DONTAYS
PLUS
BANGOR FLYING CIRCUS
FRIDAY, JANUARY 24
THOUP
PLUS
BANGOR FLYING CIRCUS
SATURDAY, JANUARY 25
ILLUSIONS
PLUS
HOT FUDGE
FRIDAY, JANUARY 31
BUFFALO SPRINGFIELD
PLUS
HOT FUDGE
SATURDAY, FEBRUARY 1
THE MAZE

JAGUAR PRESENTS

APRIL 1968

Wed. 3	CRYAN' SHAMES	plus THE GOOD EARTH
Fri. 5	THE NIGHTSHADES	plus THE MAZE
Sat. 6	BYZANTINE EMPIRE	plus STRAWBERRY EXPRESS
Thurs. 11	THE MAUDS	plus NOVA EXPRESS
Sat. 13	THE FLOCK	plus VELVET WHIP
Fri. 19	YARD BIRDS	plus FIRE DEPARTMENT
Sat. 20	CALIFORNIA PRUNE ADVISORY BOARD	plus GROSS NATIONAL PRODUCT
Fri. 26	HUDSEN BAY COMPANY	plus SHADOW CASTERS
Sat. 27	TROYS	plus GROPE

The Jaguar
12 North 3rd Street
In the heart of St. Charles
Information 584-1129
Hours 8:00 - 11:30 P.M.

Many "teen clubs" in the Chicago area handed out small cards listing the bands coming through in the upcoming months. They are a good example of the cross section of Chicago bands performing at the time, as well as an indication of a few national acts that were surprisingly still playing some of the smaller clubs. The author's band Grope appears on all three cards as an opening act. (Author's collection.)

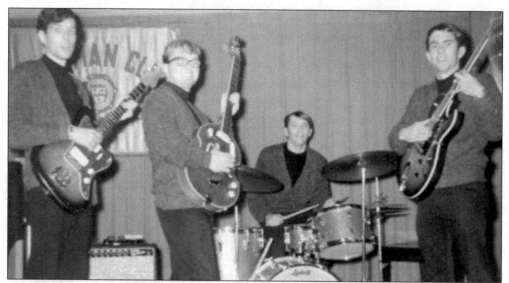

The Bossmen played rock and roll and hailed from Chicago's western suburbs. The members were Ken Utterback, who went on to play with Pacific, Gas and Electric for several years; Paul Hauptman; Cliff Carrison; and Steve Griffin. Utterback said, "I was 18 years old at the time and had fake IDs that said I was 23 which, in the mid-1960s was the minimum age in Chicago for playing clubs or bars." (Ken Utterback.)

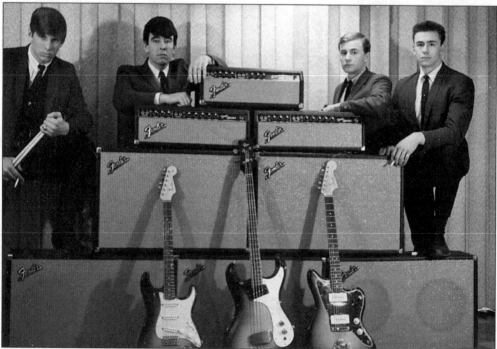

Back in the early 1960s, a band's equipment and stage clothes were almost as important as their repertoire. The Cascades were obviously proud of their Fender amps and guitars along with a unique Mosrite bass and displayed them prominently in their promotional photographs. The Niles-based band consisted of Notre Dame High School students and included Jim Ulett, Fred Kores, and brothers Greg and Rick Simone. (Rick Simone.)

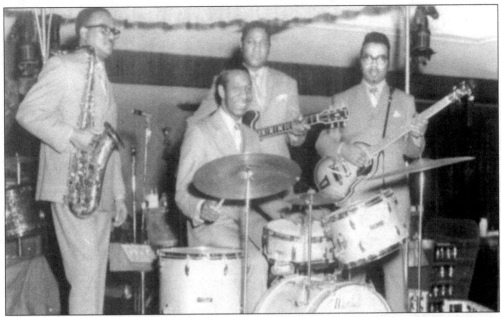

No history of Chicago music would be complete without drummer and showman Tony Smith, who has been playing the club scene since the 1940s and is still going strong. His fans love his Vegas-style shows, complete with plenty of "bawdy" jokes and rim shots. "I've been in love with the same woman for 23 years—and if my wife finds out . . ." And somehow, when Smith tells the joke, it is still funny. (Tony Smith.)

Before he became known and loved by the world through his comedy, John Belushi played drums in a rock band called the Ravens in his hometown of Wheaton. The band played the local youth center and area high school dances. Members included Belushi, Phil Special, and Dick and Mike Blasucci. Eventually Belushi's drums were sold to a local music store where they were used to give drum lessons to aspiring rock and rollers. (Wheaton North High School.)

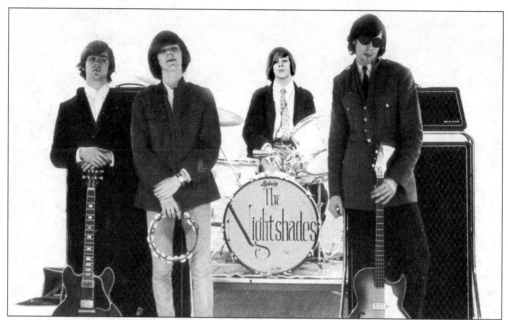

The Nightshades (originally the Deadly Nightshades) formed in Glenview in 1965. This photograph from about 1968 really reflects the new attitude that bands were starting to adopt in the mid-1960s, getting away from the smiling faces of bands from years past. From left to right are Bob Zemke, lead guitar; Larry Lacoste, rhythm guitar; Kenny Lacoste, drums; and Tom Lavin, bass. (Tom Lavin.)

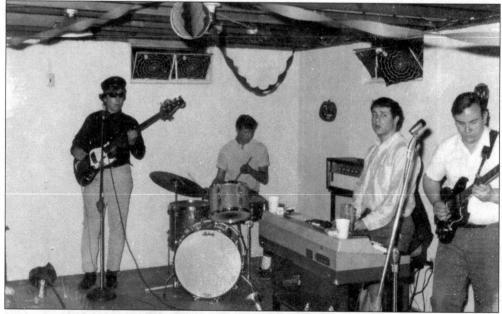

In the world of suburban rock and roll, the Escavels from Wheaton were the band everyone aspired to. They were "the pros," who played all the big high school dances, the best basement parties, and they even cut a record. They drove the local, screaming girls crazy. Various members included Ken Utterback, Stan Sherbino, Tony Pavalonis, Buzz Fhyrie, Phil Special, Dean Reber, and Chris Shannon. (Chris Shannon.)

The Other Half formed in the mid-1960s when hundreds of bands were forming throughout Chicago, hoping to ride the success of bands such as the Beatles. They even went as far as inventing British-sounding names for each band member. Personnel included Bob "Bob Regal" Siegel, Karl "Carl Benson" Meerstein, Randy "Van Karlsson" Chance, Brett "Brett London" Knopf, and Kirby "Sir John Kirby" Bivans. (Kirby Bivans.)

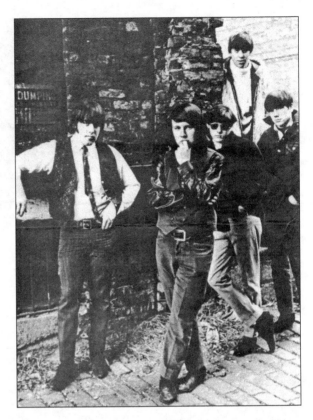

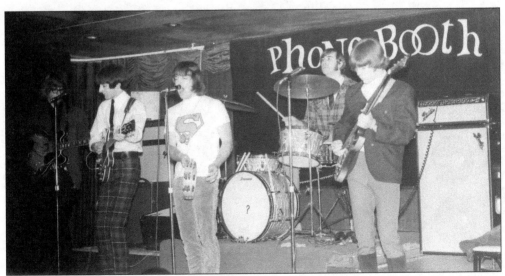

The Shadows of Knight were probably as close to a punk band as one could get back in the mid-1960s. When local radio deejay Clark Weber convinced the band to come up with a toned-down version of Van Morrison's teenage anthem "Gloria," the results produced a hit record. Pictured here in 1966 are (from left to right) Joe Kelly, Jerry McGeorge, Jim Sohns, Tom Schiffour., and Warren Rodgers (Alan Obermann.)

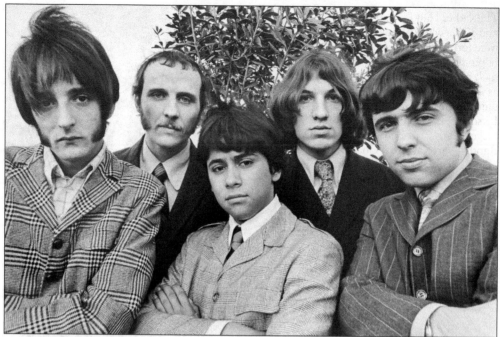

Probably one of the most unique and underrated Chicago bands of the 1960s was H. P. Lovecraft. They were short-lived, but their soaring harmonies and their delicate sound could not be forgotten by anyone who heard them. Although they had strong folk roots, they could also rock with the best of them. Band members included (from left to right) Jerry McGeorge, Dave Michaels, Michael Tegza, Tony Cavallari, George Edwards, and Jeff Boyan (not pictured). (Jerry McGeorge.)

The first time the Bangor Flying Circus performed at the DuPage County Fairgrounds in the late 1960s, the crowd was absolutely wowed. They opened with a 20-minute-long, incredibly complex number that left the audience fairly stunned. The band consisted of David "Hawk" Wolinski, Alan De Carlo, and Tom Schiffour, who was eventually replaced in 1968 by Michael Tegza. The artwork from their album cover above is appropriately distorted. (Author's collection.)

Pictured here is the band Grope. They were the rebels of the suburban high school circuit because they insisted on playing the Grateful Dead, the Doors, and Zappa tunes instead of standard Top 40 hits. Most of the kids did not like them, but the ones who did loved them. The band lasted from 1967 through 1969. Personnel in this picture are Dave Turnquist, Pat Cannon, Steve Zoellin, Bob Baum (seated on pole), Dean Milano (seated on ground), and Russ Ward. (Author's collection.)

Train was a rock-and-roll cover band that grew out of several earlier bands, including Fire and the Hang Five. The band worked local clubs and fraternity parties at Northwestern University until 1972. Members were Dave Redmond, Ken Slauf, Dave Gehringer, and Ted Wass, who eventually headed out to Hollywood when arthritis prevented him from continuing to play guitar. He starred in the sitcoms *Soap* and *Blossom*. (Ken Slauf.)

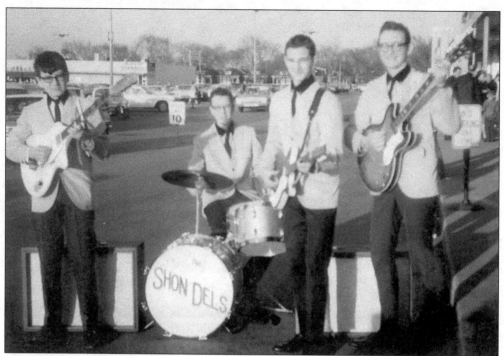

Before they were the Ides of March, they were known as the Shon Dels, another example of an early-1960s band name that did not sound quite hip enough once the late 1960s rolled around. Changes in every aspect of American culture were taking place at a much faster pace during that decade. The band appears to be playing a street party of some sort in front of a local shopping center. (Chuck Soumar/Marlene O'Malley.)

The 1960s were a time when a band from the Chicago suburb of Berwyn could have a major hit record on the Billboard charts. The song "Vehicle" by the Ides of March has since attained classic status in rock-and-roll history. Members of the band at the time of the 1970 recording were Jim Peterik, Mike Borch, John Larson, Bob Bergland, Larry Millas, and Chuck Soumar. (Chuck Soumar.)

The New Colony Six were the first in a wave of Chicago bands to crack the big time in the 1960s. Members included Ray Graffia, Chic James, Craig Kemp, Wally Kemp, Gerry Van Kollenburg, Les Kummel, and Pat McBride. Formed in 1964, after a less-than-successful shot at the California scene, they returned to Chicago where they were eventually joined by Ronnie Rice and Bruce Mattey, who penned several of their hit singles. (Ray Graffia.)

Named by *Billboard* magazine as "the most listened to band in America" in 1967, the Buckinghams were one of the more nationally successful of the 1960s Chicago bands. With a string of hit records through the latter part of the decade, members Carl Giammarese, Nick Fortuna, John Poulos, George LeGros, Dennis Tufano, and Dennis Miccolis proved that Chicago was ready for the big time. (Carl Giamarese.)

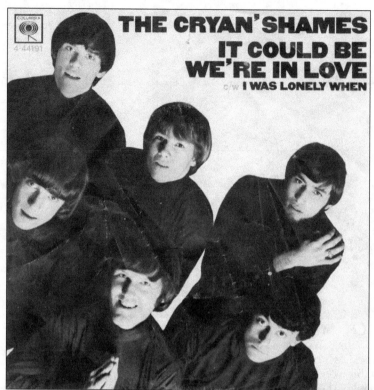

THE CRYAN' SHAMES
IT COULD BE
WE'RE IN LOVE
c/w I WAS LONELY WHEN

The Cryan' Shames were probably one of the best examples of the new Chicago sound that came along in the mid-1960s. With their tight harmonies, jangling 12-string guitars, and fresh pop sound, they hit on a formula that rewarded them with several hit records through the rest of the decade. Original members were Tom Doody, Gerry Stone, Dave Purple, Denny Conroy, Jim Fairs, and Jim Pilster. (Author's collection.)

Several Chicago-based bands were able to land record contracts during the 1960s and 1970s, and the Jamestown Massacre was one of them. Their single "Summer Sun" placed on charts all over the country and helped them to build a large fan base. This early photograph shows them performing at the Downers Grove Youth Center. Members are (from left to right) Jeff Quinn, Dave Bickler, V. J. Comforte, Dennis Carlson, John Gillerin, Glenn Messmer, and Mark Zapel. (Jeff Quinn.)

For the Boyzz, it was all about bikers, leather, and butt-kicking boogie. A seasoned bar band, the Boyzz eventually signed with Epic records and released their debut album, *Too Wild To Tame*. The album received mixed reviews, but the fans were rabid regardless, and the band played on for several more years. Members included "Dirty" Dan Buck, Gil Pini, Dave Angel, Anatoly (Tony Hall) Halinkovich, Kent Cooper, and Mike Tafoya. (Mike Tafoya.)

The Flock was a promising jazz/rock group that never reached its potential even though it released two fine albums on Columbia Records in 1969 and 1970. Band members included Fred Glickstein, Jerry Goodman, Jerry Smith, Ron Karpman, Rick Canoff, Tom Webb, and Frank Posa. A major blow came to the group when Goodman, who played electric violin, left to join the Mahavishnu Orchestra. (Richard Levee.)

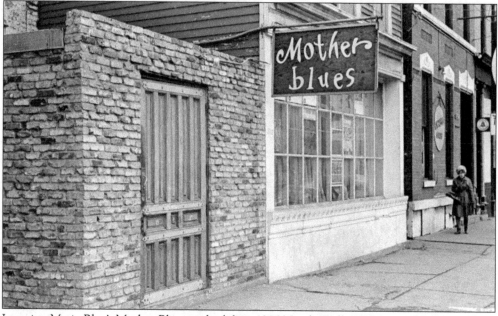

Lorraine Marie Blue's Mother Blues nightclub at 1305 North Wells Street was *the* place to hear great music in the Rush Street/Old Town area during the 1960s. Janis Joplin, Muddy Waters, John Denver, and Jefferson Airplane were just a few of the performers who graced the stage. The club was closed by the city for dubious reasons during the 1968 Democratic Convention and never allowed to reopen. (Larry House.)

They were a bunch of guys calling themselves Gary & The Nite Lites, but they soon became known as the American Breed, complete with hit singles and a national reputation. The original Nite Lites were Gary Loizzo, Charles Colbert, Al Ciner and Lee Graziano, but once they changed the band's name, things began to happen with the song that put them on the map- "Bend Me, Shape Me". After adding Kevin Murphy and Andre Fischer, the band eventually morphed into Ask Rufus and then simply Rufus. (Gary Loizzo.)

There seems to be a market for 45-rpm records cut by Chicago bands of years past. A single, titled "You're a Better Man Than I" by the Outspoken Blues, a popular band from the northern suburbs, recently sold for $500 on Ebay. Incidentally, the band played more rock and roll than they did blues. They just happened to like the name Outspoken Blues. (Gilbert Ross.)

The Mauds recorded albums for Dunwich, Phillips, and RCA during their career, but it is interesting to note that they were the first white soul/rock band to record at Chess studios for their debut album, *Hold On*, on the Mercury label. The Mauds consisted of Denny Horan, Fuzzy Fuscaldo, Tim Consiglio, and Bill Sunter, but lead singer Jimy Rogers was the lifeblood behind the band. (Joan Gand.)

The Blackstones came together in early 1965, and unlike many local cover bands, they immediately set about writing their own material and released several singles on the Invictus record label. Band members included Tom Osborne; David Blanchard, who was drafted into the military later that year; Geoff Boyan, who later joined Saturdays Children and H. P. Lovecraft; and Jerry McGeorge, who later joined the Shadows of Knight and H. P. Lovecraft. (Jerry McGeorge.)

Saturday's Children was formed in 1965 by Geoff Boyan, along with fellow musicians Ron Holder, Gerry McGeorge, Rick Goettler, and George Pall. The following year, Dave Carter was added to the lineup and things began to look up, as the band was signed by Dunwich Records. After several singles failed to chart, however, the band was dropped by the label and eventually broke up. (Nancy Lutz Harless.)

Originally named Big City V, For Days and A Night was a smooth R&B band that went through as many as 50 different musicians throughout its history. Its manager, Nick Vitullo, was in charge of keeping the sound together through the myriad of players who passed through the band. They were also a racially integrated band at a time when that was not readily accepted. (Larbi Ruslan.)

Alaric "Rokko" Jans and Annie Hat made the Bulls their home base and held the Sunday night slot there during the 1970s. With roots in the Chicago theater scene, they were a favorite with actors and all who loved the inimitable vocal stylings of Annie and the band's eclectic brand of cabaret rock, featuring original songs by Jans and Elliott Delman. They often performed as Rokko and the Hat Band, with additional musicians. (Michael James.)

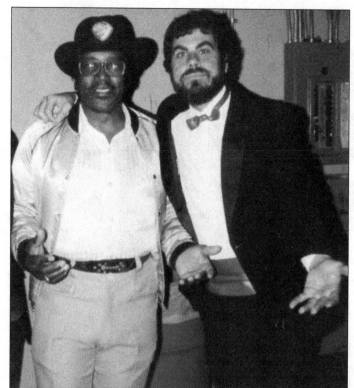

Bo Diddley was known as "the Originator," due to his role in the transition taking place from blues to rock and his influence on the next generation of musicians. He became famous for his "shave and a haircut" driving rhythm and hard-edged guitar sound. When the author shared the stage with him in 1979, Bo Diddley told him he was tired of the beat he had become known for, but years later he revived it again. (Author's collection.)

Rich Markow and the Living Cartoon Orchestra consisted of (from left to right) the original Living Cartoon, Markow himself, Brian Mott, "the Fabulous Chester," and Shelly Plotkin. Described by one agent as "a cross between Spike Jones and the Marx Brothers," the trio backed Markow and participated in his zany routines interspersed with bassist Chester's deadpan humor, Plotkin's drum showpieces, and Mott's good time rock-and-roll piano and vocal. (Faith Bennett.)

T. S. Henry Webb was Tom Webb's short lived rock and roll band in the early 1970s. Oddly enough, he soon left his own band after a dispute with his record company regarding the direction of the band and Tom Webb then went on to join another Chicago band, the Flock. The remaining members formed the Eddie Boy Band in 1974. Both T.S. Henry Webb and Eddy Boy Band performed regularly at Wise Fools Pub and Ratso's and were known for their onstage antics as well as their music. Eddie Boy was one of the more successful Chicago bands, recording an album with MCA records and opening for many of the big name bands coming through town, including a one night stand as Chuck Berry's back-up band. Band members included Josh Leo, Mark Goldenberg, Tim Walkoe, John Paruolo, Denny Ebert and Mike Lerner. (Mike Lerner.)

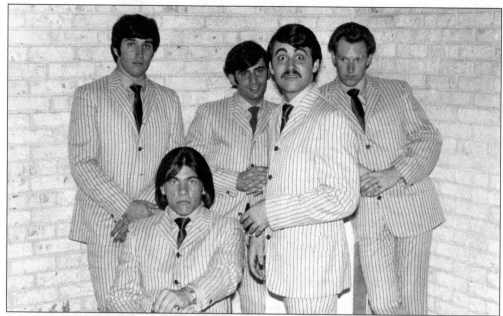

Originally called the Cave Dwellers, it was decided a more appropriate name for this 1960s rock-and-roll band was the Revelles. Over the years, several members moved on to join the Cryan' Shames and New Colony Six. Band members in this picture are Ralph Millin, guitar; Victor Alfonso, keys and vocal; Marty Pichinson, drums; Bruce Mattey, lead guitar and vocal; and Bruce Gordon, bass and vocals. (Bruce Mattey.)

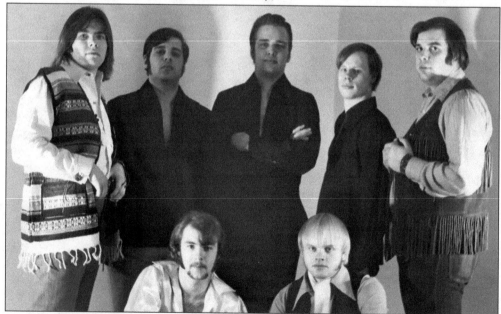

C.A.R.E., originally a seven-piece show band, stands for the Creative American Rock Ensemble. The large band worked the Rush Street area starting in the late 1960s, but due to the economics of the times, it eventually downsized to a trio, continuing to perform through the 1970s. Players included Bruce Mattey, Gary Greenman, Gary Langwell, Ken Jacobson, Mark Fript, Bob Skolmoski, and Don Lehman. (Bruce Mattey.)

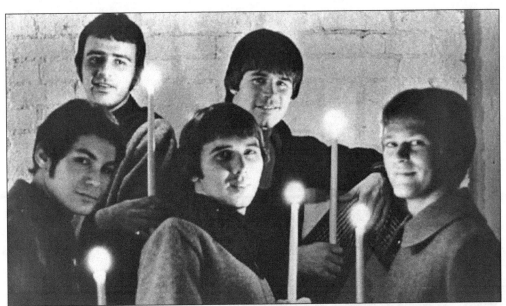

Like many bands that found their original names suddenly outdated in the late 1960s, the rock band the Rovin' Kind (above) decided to change its name to Illinois Speed Press (below) in 1968. Success was on the horizon with the name change, but it was short-lived. The band played at the first-annual Newport Pop Festival and was quickly signed to Columbia records. Their first album, *Illinois Speed Press*, charted at No. 144, but soon after, the band began to fall apart once some of the members got a taste of the thriving West Coast music scene. Several members left and were replaced, but the second album, *Duet*, did not fare as well as the first. Original Illinois Speed Press band members were Paul Cotton, Kal David, Mike Anthony, Bob Lewine, and Fred Page. (Kal David.)

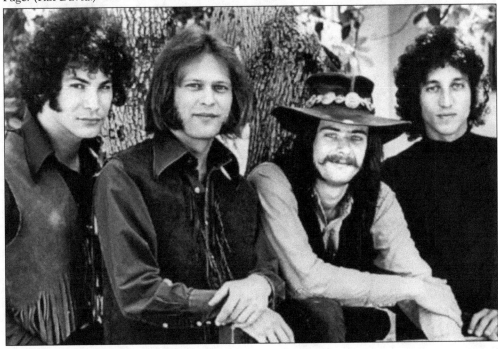

If San Francisco could have a Be-In, one can bet Chicago could have one too. The countercultural movement was gaining momentum across the country, and 3,500 people showed up in Lincoln Park on May 14, 1967, to take part in the Be-In and to hear several local bands, among them the Griffith-Harter Union. Band members that day included Gary Peterson, Matthew Warman, Randy Harter, and Larry Costello. (Larry House.)

During a time when music was considered the sole property of the people, many bands devoted themselves to social and political causes. One such band was Killin' Floor, spearheaded by Michael McGraw. The band played for many Rising Up Angry events and eventually became involved with the Cooperative Energy Supply organization, which was dedicated to bringing neighborhoods together for social awareness. Band members included (from left to right) Chuck Pasdach, McGraw, Mick Demikis, and Larry Galman. (Mike McGraw.)

In 1968, Warren Leming and Nate Herman, along with Andy and Tom Haban, formed Wilderness Road, a band that was more than just a band in that it performed elaborate stage shows as well as playing great music. The band was also deeply involved in the political and social movement taking place in the late 1960s, participating in several benefit concerts for the Cooperative Energy Supply organization, among others. (Warren Leming.)

After he had performed with his band The Knaves, Howard Berkman played with the unusually named Yama and the Karma Dusters. The band was one of several, along with Wilderness Road and Killin' Floor, committed to support of Michael James "Rising Up Angry" political events. Band members at this 1970 Miller Meadow Rock Festival include Berkman, Neal Pollack, Al Goldberg, Karen Tafejian, Louis Favors and Bob Goodfriend. (Al Goldberg.)

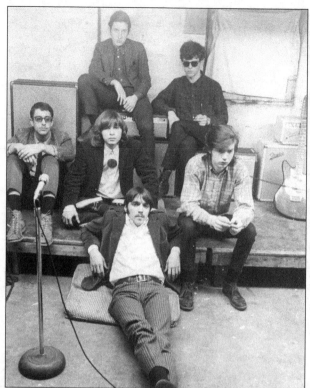

They started as a bluegrass trio, but "when Dylan went electric in '65, so did we!" according to Justin Pomeroy, founder of the Dirty Wurds. Hard to categorize as blues or rock, the band could easily be called one of the first real punk bands. Members included Pomeroy, Mike Peterson, Jim Savage, Mark Bringman, Mick Mackles, and Mark Hannon, who went on to form his own blues band after the demise of the Dirty Wurds. (Justin Pomeroy/Scott Smith.)

The United Nations was probably one of the largest bands in the city and one that would be almost impossible to turn a profit in today's market. The jazz/rock band prided itself on its cross-cultural mix of players and included George Galanos, Gary Krutz, Sherry Hill, Rich Levee,

Jerico was described as a powerhouse band with blues, rock, funk, classical, and jazz influences, sharing the stage at times with the likes of Ginger Baker, J. Geils, Slade, and other rock bands. The band formed in the 1960s and disbanded in 1975. Early members included Scott Williams, Frank Gil, Jack Fitzgerald, Bill Sosin, Gavin Christopher, and Jimmy Benson. Later members were Jack Skalon, Joe Cuttone, Glenn Rupp, Bill Jordan, and Imre Silas. (Jack Skalon.)

jerico

Rock Music from Chicago

Bill Jordan - Vocals
Joe Cuttone - Bass, Vocals
Imre Silas - Keyboards
Glen Rupp - Guitar, Vocals
Jack Skalon - Drums

Jim Yamauchi, Shopan Entesari, Erwin Yasukawa, Dean Rolando, and John Osborne, and alumni Dave Huizenga and Marc Cooper. (Dean Rolando.)

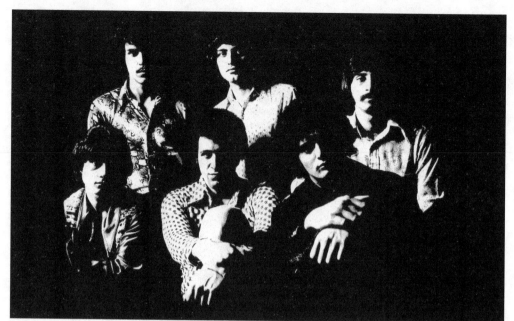

Eden Rock rocked Chicago from 1969 to 1976 with an experimental sound using hard-hitting rhythms and full vocal harmonies. They recorded two single records, "Nice To Be Together" and "In Paradise." The band performed at every high school, college, nightclub, and teen club in the Chicago area, and members included Michael Walker, Phil Barrile, Robert Camastro, Jack DeFiore, Frank Lombardo, and Al Sofia. (Phil Barille.)

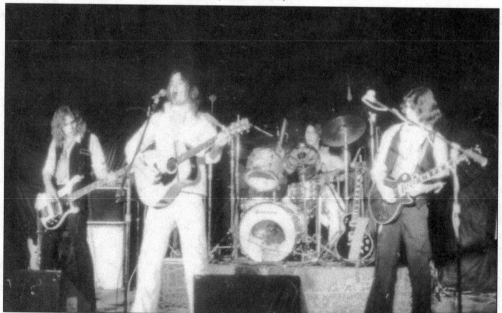

Mesa formed in 1975, playing the Chicago club circuit as well as Chicago Fest and other events. They eventually won two cuts on the *WKQX Hometown Album II*, quite an accomplishment at the time. The band stopped playing full time in the 1980s but still plays currently under the name Brothers and Others. Band members included Rob Kleeman, Chip Trindl, Tom Cloud, Matt Casey, Tom Kleeman, and Pete Spero. (Rob Kleeman.)

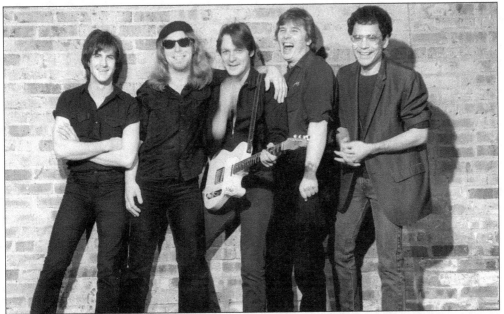

When Mike Jordan was not singing folk music, he had his own rock band, Mike Jordan and the Rockamatics. Angelo Varias said, "Mike Jordan was 'the man.' He wrote it, played it and presented it like nobody's business. I can still see that Chuck Berry autographed Fender go flashing by me, as Mike leapt from the top of a speaker stack." From left to right are John Siegel, Tom "Pickles" Piekarski, Jordan, Tim Tobias, and Angelo Varias. (Angelo Varias.)

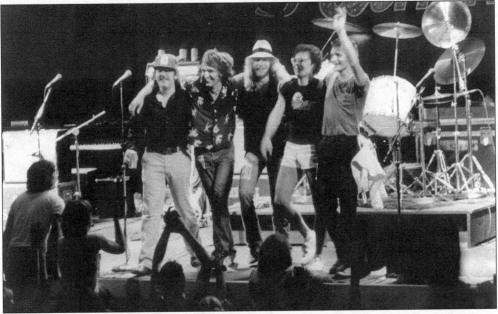

The Famous Potatoes doubled as John Prine's touring and recording band and rode the Roots Revival through the 1970s. Varias said, "We'd out-crazy everybody, taking on the Blasters at Minstrel's to Jerry Lee Lewis himself at the Metro. The energy made people drink a lot, so we were a big hit with rowdies and bar owners alike." From left to right are Bob Hoban, John Burns, Piekarski, Varias, and Jordan. (Angelo Varias.)

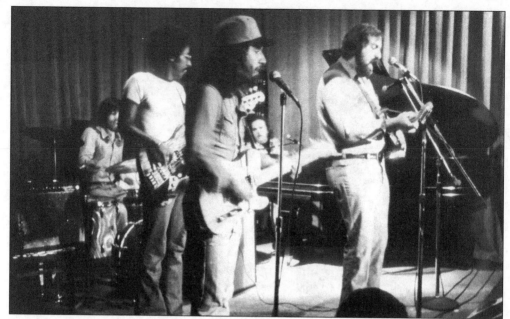

Singer/songwriter Ron Crick moved to Chicago along with guitarist Josh Leo in 1971, and the two started playing the local club scene, eventually adding Simeon Pillich on bass. Crick said, "One night we showed up at Orphans for a performance and there's a piano and drums on stage. Suddenly Bob Hoban and Kirby Bivans are playing with us and it worked! To this day I have no idea who called them." (Kirby Bivans.)

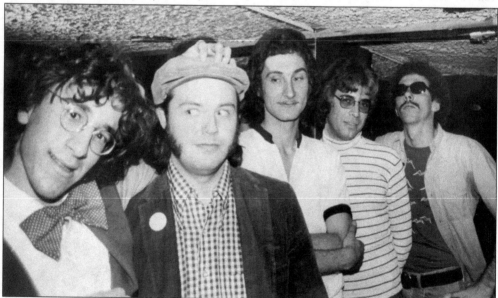

During the 1970s, Huge Hart's jaunty pop music attracted critical raves, radio play, and a devoted fan base. Wise-cracking singer/songwriter/piano man Hart, bassist Jim Morris, guitarist Bruce Barrett, and drummer Mark Duran charmed crowds with "rock-meets-vaudeville" tunes documented in their *Live! More of the Best of Huge Hart's Greatest Hits: Volume II* album. Alumni include Todd Reber, Phil Ghallaghan, Steve Fidiuk, Roy Toepper, and Ray McKenzie. (Jim Morris.)

Ronnie Rice is one of the true characters of the Chicago music scene. Playing the part of a living jukebox, Rice's shows can become one big "stump the band" exercise, and audiences love it. After writing hit songs as lead singer for the New Colony Six, he went on his own in the 1970s, performing on the club circuit and making a name for himself doing voice-overs for radio and television advertisements. (Ronnie Rice.)

AN EVENING WITH. . .

RONNIE RICE

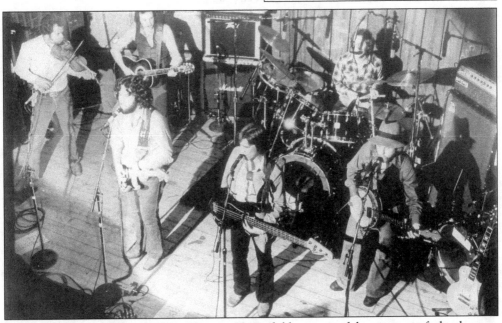

Formed in 1972 in south suburban Chicago, Heartsfield was one of the pioneers of what became country and Southern rock. With all six members writing and singing, they were signed in 1973 by Mercury Records and in 1977 by Columbia Records, selling a few million records and performing at over 4,500 events. This photograph was taken in 1973 with J. C. Hartsfield, Perry Jordan, Phil Lucafo, Greg Biela, Artie Baldacci, and Freddie Dobbs. (Dick Reck.)

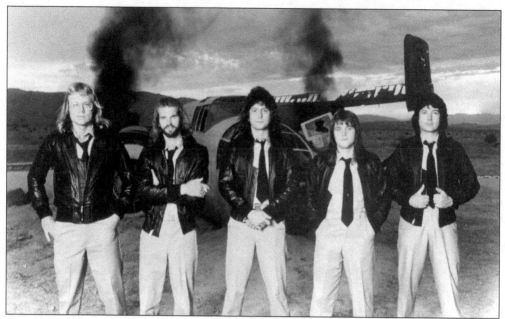

Survivor was born in 1978, founded by Jim Peterik, Gary Smith, and Dennis Keith Johnson. Frankie Sullivan and Dave Bickler were eventually added, and after playing the local club circuit for a time, they recorded their debut album. The album was not as successful as hoped, but after several years and several personnel changes, the band hit it big with their single "Eye of the Tiger," the theme song for the film *Rocky III*. (Gary Smith.)

Graced Lightning was a progressive, all-instrumental rock band from 1971 to 1976, performing as regulars at all the Lincoln Avenue clubs. Leader and guitarist Gary Gand said, "We recorded one album—actually only one side of an album, called 'The Graced Lightning Side.' I hear it's selling for ridiculous amounts of money to collectors. It's so rare, I don't even have a copy!" Members included George Edwards, Chris Herman, Joan (Burnstein) Gand, and Gand. (Joan Gand.)

Mountain Bus's claim to fame is that they were sued by the band Mountain for stealing the band's name, when in reality, Mountain Bus had been using the name a few years before Mountain even formed. The lawsuit proved effective when the band's label, Good Records, went bankrupt trying to fight it, and Mountain Bus broke up as a result. Band members included Ed Mooney, Tom Jurkens, Steve Krater, Bill Kees, and Craig Takehara. (Craig Takehara.)

Pentwater was a progressive rock band formed from several north suburban rock and blues bands. Chicago-based Dharma Records signed them to a four-record deal in 1974, but the label went bankrupt before recording could begin. Three independent releases ensued, and over the years, the band toured with Rush, REO Speedwagon, Journey, and many others. Members included Tom Orsi, Ron Fox, Phil Goldman, Ken Kappel, Ron LeSaar, and Mike Konopka. (Phil Goldman.)

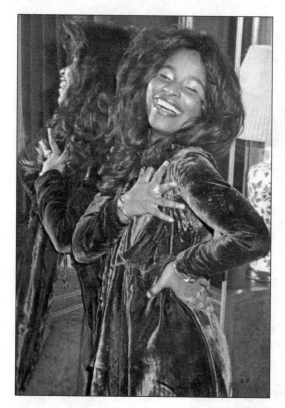

After the Crystalettes and Lyfe and the Babysitters, Yvette Marie Stevens, better known as Chaka Khan, finally found success with the soul band Rufus. With a little help from Stevie Wonder, several of their singles broke onto the charts, and the band, with Khan upfront, became one of the biggest R&B bands of the 1970s. The singer's red lips even became the logo of the band. (Guy Arnston.)

No one who ever heard the voice of Minnie Riperton could ever forget it. It was unique, and when she died at a young age, the wonderful voice was stilled forever. She sang with the Rotary Connection from 1967 through 1971, when the band split up, and she embarked on a solo career for several more years. Her voice lives on through her many recordings and the 1975 hit single "Lovin' You." (Guy Arnston.)

During the 1970's Park Ridge native Dick Eastman led a stellar band which included (left to right) Ron Kaplan, George Kohl, Eastman, Dean Rolando, and Bobby Diamond. They opened shows for Roy Orbison, the Dixie Dregs and Rory Gallahger, among others. Eastman eventually moved back and forth between Chicago and Los Angeles, becoming a staff songwriter for MCA Music and along with the legendary Bobby Hart, he co-wrote songs for The Monkees, New Edition, Robbie Nevil, and LaToya Jackson. (Guy Arnston.)

The Ashby-Ostermann Alliance was a heavier than average Fusion band. Their Art Rock/Jazz sound didn't transfer well to recordings, but the band delivered a great live show and was very popular with Chicagofest audiences. Personnel included Dennis Ostermann, Vince Ashby (seen in this photo), along with James Bromley, Jim Massoth, and Jim Hines. (Guy Arnston.)

Named after their southside neighborhood, Roseland was formed by ex-Vibratone guitarist Paul Petraitis, pianist Ron Hoeller, ex-Mutations guitarist Ron Woodward, drummer Steve Jones, ex-Stepchildren guitarist Barry Soliday, bassist Rick (R. Y.) Young, and lyricist Ray Brandle. In 1972, Roseland switched bassists with Fawn, acquiring Jim Williams, and replaced Woodward with saxophonist Billy Poole. By 1973, when this photograph was taken, Poole had been replaced by organist Charlie Palumbo. (Paul Petraitis.)

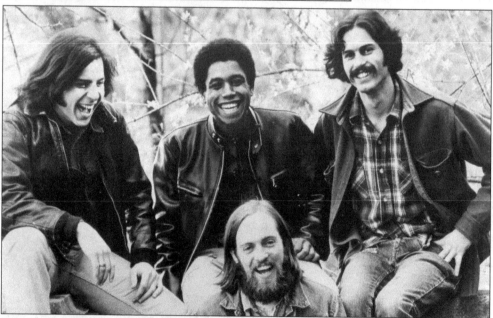

They were described as "riding the thin line between hard Folk and soft Rock." And so Redwood Landing gained their reputation as an "un-brandable" band, and that is how they liked it. Incorporating smooth harmonies and top-rate musicianship into a myriad of styles, Mitch Meyerson, Neal Howe, George Potts, and Ron Kaplan formed the nucleus of a band that became a Chicago favorite during the 1970s. (Ron Kaplan.)

ADDENDUM

Below is a list of some of the bands and musicians whose photographs do not appear in this book but in a perfect world would have been included along with their fellow musicians whose images grace these pages.

Folk:
Above the Storm
George and Gerry Armstrong
Ed Balchowsky
Ken Bloom
Jim and Vivian Craig
Louise Dimicelli
Carolyn and Peggy Ford
Dennis Gordon
Kendall Kardt
Mississippi Flanagan
Lee Murdock
Kathy O'Hara
Terry Rebenar
Redhead
Claudia Schmidt
Dwayne Story
Valuscha
Harry Waller
Amy Wooley
Dan Zahn
Amy Lowe

Blues:
Jimmy Davis
Mark Hannon
Hound Dog Taylor
J. B. Hutto
Freddie King
Buddy Miles
Jimmy Reed
Simtec and Wylie
Willie "Big Eye" Smith
Otis Spann
Them Somewhat Familiar Blues Band
Third Rail

Country:
Baraboo
Bitter Creek Newgrass Band
Don Barnett and the Nu-Jays
Jimmy Nichols and the Nashville Cats
J. J. Dickens and His Black Cowboys
Midnight Special
Phlagg Williams and the Road Rangers
Pony Express
Prairie Union Bluegrass Band
Ray Hilburn and Coyote
Red Ratliff
Southern Sounds

Jazz:
The AACM
Bob Stone Band
Anthony Braxton
Oscar Brown Jr
Bobby Christian
Dave Major and the Minors
Denise Osso Ensemble
Don Demicheal Swingtet
Ezra Quantine Ragtime Memorial Band
Von Freeman
Ghalib Ghallab
Franne Golde
Jazz Gumbo
Chuck Hedges
Larry Novak
Russ Phillips
Bill Porter Band
Roger Pemberton Band

Bobby Schiff
Shy Rhythm
Milt Trenier
Marshall Vente

Rock:
Aliotta, Haynes and Jeremiah
Aorta
Fifth Street
Flight
Getcher Kicks
The Knaves
Little Boy Blues
The Mead
The Mob
The Morning After
Ted Nugent
Pirhana Brothers
The Riddles
Software
Spanky and Our Gang
Styx
Swanee Hacker
Talisman Ring
Vanessa Davis Band
Virginia Klemmens Band
The Daughters of Eve
The Marie Antoinette's

Visit us at
arcadiapublishing.com